Dances At Moonrise

Jim DiNapoli

L A U R A J A N C A

Order this book online at www.trafford.com
or email orders@trafford.com

Most Trafford titles are also available at major online book retailers.

Print information available on the last page.

ISBN: 978-1-4907-6777-2 (sc)

Trafford rev. 12/23/2015

www.trafford.com

North America & international
toll-free: 1 888 232 4444 (USA & Canada)
fax: 812 355 4082

Contents

This book is a series of trip reports by Jim DiNapoli. Jim summited all 58 of the ranked 14ers in Colorado. He also had 44 of them completed in calendar winter and had hoped to finish them in the 2014-2015 year. At that time he would have been only the 6th person to make this accomplishment. Sadly, he was diagnosed with pancreatic cancer in November of 2013 and passed away in March 2014.

Though he is no longer with us, his trip reports were legendary within the 14ers community (www.14ers.com) and those who were fortunate enough to hike with him held him in high regard for his alpine skills. He was known for his speed and strength in climbing. Another unusual fact about Jim's ascents of the 14ers is that he never used a GPS or carried a cell phone. He did them all with only a map and compass. Many of his ascents were done solo. He was very humble about his accomplishments and always gave much credit to his climbing partners. Dances at Moonrise was his "handle" on the 14ers website and so it seemed an appropriate title for his book.

Britt Jones, a very close friend and climbing partner wrote the following:

Jim was amazing as a mountaineer. Why? Because he was fast! He liked to sleep in his own bed at home, then drive to the trailhead and start later than everyone else, and yet he would still beat most of us to the summit! Add to that his rock climbing skills, and he was able to get up most any mountain and most any route. And lastly, Jim was in-progress of going after all the Colorado 14ers in winter. It takes a different type of person to climb in winter. Add to that, Jim did most of his winter 14ers solo.... which also takes a truly, different type of person. Jim was amazing!

I wanted to publish these stories to both honor Jim and to show his talent. In addition to his mountaineering skills, Jim tells these stories with humor and includes some amazing photography. Many photos were taken while he was on a ridge with full exposure on either side! Climbing these mountains in winter is one thing, but crossing a ridge with drops on either side of a thousand or more feet yet taking the time to pull a camera out of your pocket to snap a photo takes a special kind of person. A passionate

person. Jim was very passionate about every undertaking. He never gave less than 100 percent. Yet, as accomplished as he was, he never took himself too seriously. I have to agree with Britt that he was truly amazing in many ways. I hope you enjoy the book as much as the many 14ers folks and myself have over the years. If you are like me, as you read you will feel as if you are right there with him on these amazing journeys.

The "Secrets of Gray Needs and other stories" is dedicated to Steve Gladbach. Steve was a very skilled mountaineer who mentored Jim as he began climbing 14ers. Jim looked up to Steve and talked about how much he enjoyed climbing with him. Sadly, Steve passed away after an accident in the mountains in 2013. Less than a year before Jim passed away from his cancer battle. Some folks in the mountaineering community are still in shock by the loss of two great mountaineers in such a short time.

- Laura

Winter Contemplation:
Wetterhorn and Uncompahgre

Peaks: Wetterhorn Peak, Uncompahgre Peak
Date: March 19, 2013
Route: Matterhorn TH to Wetterhorn, SW slopes to Uncompahgre
Approach: Hensen Creek Road
Length: ~20 miles RT
Vertical: ~7000 feet
Total time: ~14 hours
Ascent Party: Greg (Summit Lounger,) Jim (Dancesatmoonrise)

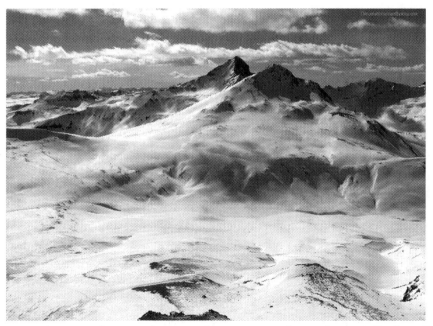

Wetterhorn and Matterhorn Peaks are seen from the SW flanks of Uncompahgre.

OK, I admit it. Wetterhorn had me smitten from that very first sunny day we met, on Thursday, June 17, 2010. The whole trip was a hair-brained scheme entirely predicated on avoidance of excessive driving.

By this point I'd already figured out my life would be hopelessly empty, unfulfilled, lacking, incomplete, unrequited, deficient, insufficient, unconsummated, imperfect, lackadaisical, rough, rude, lewd, and indecent without at least having made the effort to step foot on each and every one of Colorado's 58 14ers. But why in the world my soul had suddenly felt it could not possibly be at peace with the planet, after nearly six decades of wandering around on its surface, and even with occasional forays into those hallowed places where the last remnants of earth meet sky, remained an inexplicable Quandary. I'd no idea why I had the blues for Greys or felt partly cloudy without Sunlight. I'd already poked around Pikes but still longed for Longs, sniffled for Sneffels, howled for Handies and growled for the Challenger of Little Bear. Honestly, it was quite the Conundrum.

I knew not why, but only that it was so. No sense in putting up a fight, or feigning indifference, or attempting to quietly sneak away from it. Besides, in the prior ten months, I'd already managed to attain about half the goal anyway, so I figured, let's just go ahead and give destiny her way, indulge the whim, and let the soul go along its merry way. But the San Juan remained. And isn't it a pretty long drive?

So one night, in a feverish fit of logic over synchronicity, a plan hatched. Fourteen San Juan peaks. Three general areas. Nearly half just in the western portion of the San Juan. Equals one trip, half down. Perfect. One only has to drive down for San Luis in the afternoon, run over to Hensen Creek that night for Wett and Unca the next day, then over to American Basin that night, for Handies in the morning and Redcloud and Sunshine in the afternoon, and then head back home that night, to get nearly half the San Juan in one easy, 2.5 day trip. Right?

Well if the pace didn't smoke me, Wetterhorn did. As I made way back down Uncompahgre and westward, back into the Matterhorn drainage, on that warm gorgeous June afternoon, I gazed in deep

lust for a return to Wetterhorn. I sat and looked at the peak for a long time, wondering what it might look like in winter. Getting back to the car at last light, it was painful to leave that pristine little campsite on the Hensen Creek Road.

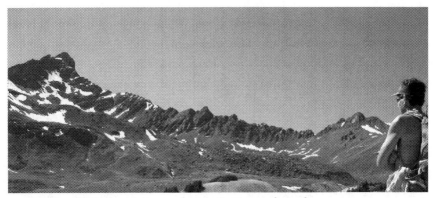

June 2010: "Winter Contemplation." Since that first warm summer's meeting nearly three years ago, Wetterhorn has beckoned a winter return.

The whole 14er chapter culminated on a bright, brisk, colorful fall day in the Elk range, in a solo effort on Capitol Peak. My soul was finally complete.

But what they don't tell you is that when you finish the 14ers, even though allowed a brief period of personal satisfaction and serenity, the addiction fails to abate. A compelling urge sets in to go to harder and more powerful drugs - I mean peaks. Like the 13ers. Well, by golly, I wasn't going to let that happen to me. Heck no, that's dangerous. I'll just stick to the winter 14ers.

I mean, having started this whole 14er quest thing in the snow season, it only made sense to continue with the winter 14ers. If you can call that sense. My old girlfriend would beg and plead with me not to go, but she was so proud when I'd return successful. It was schizophrenic. Though she did ask if I would take up something less risky, like race car driving.

The 2012-13 winter season was a bit rough for peaks. The Colorado Avalanche Information Center had put out significant watches and warnings through the balance of the season. Waiting out peaks can be frustrating.

Finally, in the last week of calendar winter, temps warm up and conditions stabilize. I seize a half-reasonable opportunity to attempt four of the season's ten peaks in just the final six days of winter. The universe is lumpy. So too, Colorado winter conditions are a quantum thing.

Returning home from Sneffels and Handies on the last weekend of winter, the car is a huge mess from camping the past three days. Greg and I had talked about Wetterhorn, but it hadn't happened. I'm tired, and ready to call it good for the season. Still, that's only eight peaks this winter, the lowest count in the past four years of winter 14ering.

Two days of winter remain. I'm on edge. Can I just let Monday and Tuesday slip by, content to quietly sneak into spring? Wetterhorn and Uncompahgre still beckon. Fitful sleep, taunted with visions of Wetterhorn and Uncompahgre.

Of course you know you wouldn't be reading this if there were no trip. Ultimately, synchronicity shines despite our most brilliant efforts.

I meet Greg at the Hensen Creek winter closure Monday night, where he has just returned from three miles up the road by bike, reporting that we can drive at least that far tomorrow morning.

My usual philosophy for driving on snow to trailheads is that one's time is often better spent hiking than digging. But if we hoofed it from the winter TH tomorrow, we'd be looking at something close to 30 miles on the day. Which is why I brought two shovels.

Well, yes, we get stuck, and that costs us some time. But we get to within three miles of the summer TH, saving us about two hours on the day. Well, minus the hour getting stuck. And maybe

wondering about the drive back out tonight. Come to think of it, mountain bikes are sure easier to dig out...

Seems it takes forever to get to the summer TH, but once there, things level out to a smooth clip.

We're in luck. Great day, great weather, and we've got a nice moon tonight. This is doable.

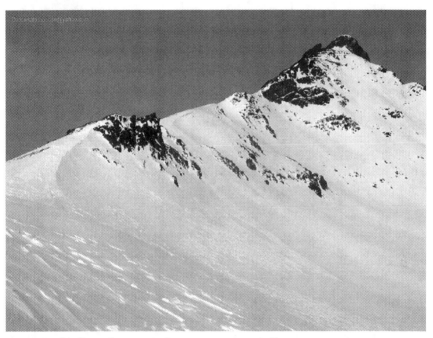

Nearing the first objective, things are going well.

Late season can be a good time to get winter peaks. The third-class section on Wetterhorn is south-facing and free of snow. The steeper part below the Prow has a few sketchy spots on steeper terrain where the snow does not hold an axe well, though much can be avoided on nearby dry rock.

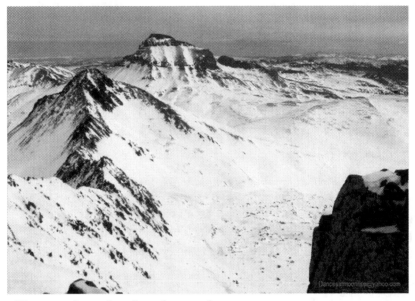

We'll worry about that thing later today.

Soon we're on Wetterhorn's compact, friendly summit. Greg, of course, is already eying Uncompahgre. He has a plan.

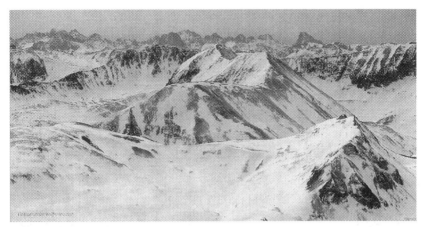

Needles in the distance behind Cinnamon Mountain.

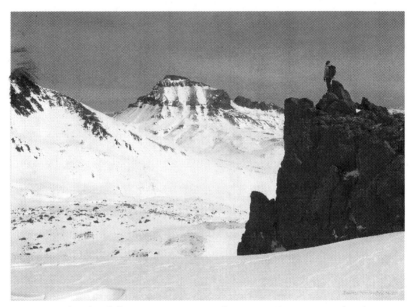

Greg wants the third finger on Uncompahgre. Can't we just take the weenie way around the back and get home by moonlight?

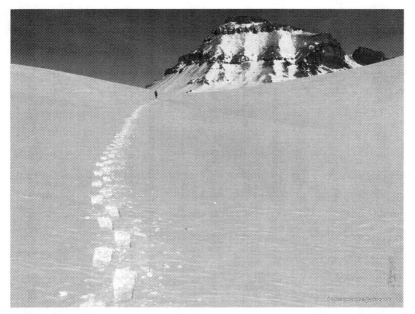

The Uncompahgre Direct. A daunting proposition after coming this far, but then, it is the last full day of winter..

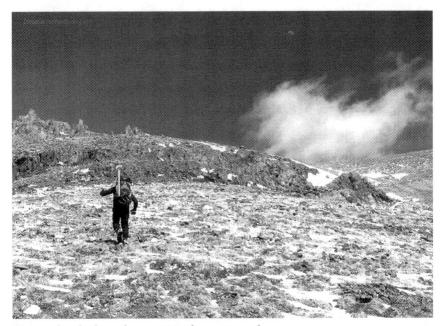

Moon, clouds, hoo-doos... Must be getting close.

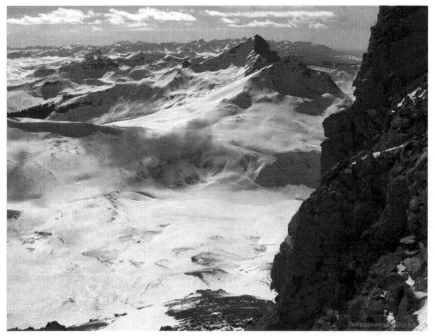

Didn't seem as far as it looks.

Incredible day. Greg's a motor; kept us both motivated and moving. Thanks, Greg!

We spend a few minutes enjoying Uncompahgre's summit in winter, slightly ahead of schedule. Everything seems in our favor. The snow is stable, the weather clear, and a half moon promises overhead light at sundown.

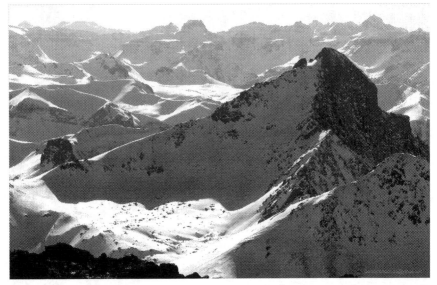

The difference in elevation is apparent. From the Uncompahgre summit, we gaze down upon Wetterhorn. Hard to believe we were there just this afternoon.

We were able to boot-glissade stable snow, picking up some time.

The long road home never felt better, as we bid a gracious farewell to winter.

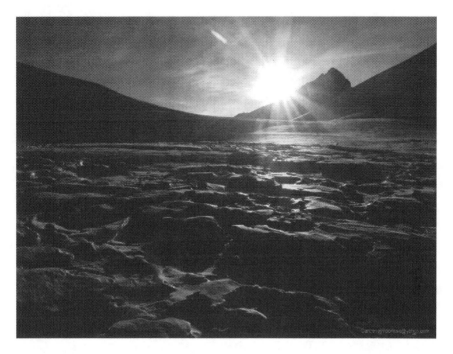

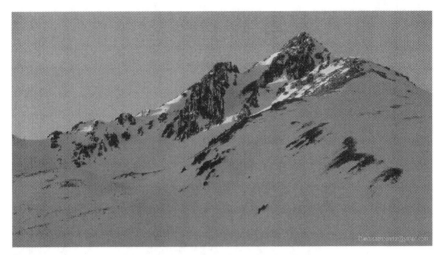

Last rays.

Then, just before last light, Greg breaks a rivet on his snowshoe. The binding falls off.

Who would think such a simple failure could be so potentially serious? It's winter. Can't get through this stuff without float. The warm afternoon gives way to evening's frigid temps. We're getting chilled just trying to fix the binding. We both have winter bail-out gear, but would rather not test it tonight.

We try some alpine cord. The abrasiveness of the snow destroys it in less than a hundred yards. We try re-tying with a large knot in each exposed end, running the cord on the non-snow side. This works better, and seems to hold up. Even with snowshoes, there's typical late day post-holing. We keep fingers cross and keep trudging. The moon serves us well. The road is long.

After ages, we arrive at the car. Surprisingly, I don't get the darn thing stuck on the way out. We're feeling good sorting gear at the winter closure after a long, satisfying day in some of the state's most beautiful mountains.

We don't part ways for the drive home till something like 10pm. I already knew work tomorrow was going to be rough. But we pulled off two moderate winter 14ers in a day - and even better - on the last full day of winter.

Greg, thanks for a great trip!

Half Cup o' San Juan:
The 56 Hour Sampler

Peaks: San Luis, Wetterhorn, Uncompahgre, Handies, Redcloud, Sunshine
Routes: Standard, except Uncompahgre from Matterhorn TH.
Dates: June 16-18, 2010
Length: 53.2 miles RT
Vertical: 17,700 feet
Total hiking/climbing time: 23 hours
Total time including camping/driving between peaks: 56 hours
Ascent Party: Dancesatmoonrise

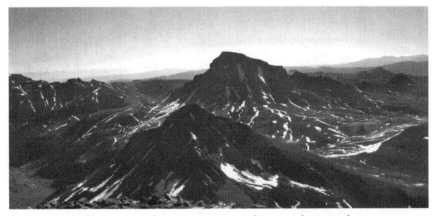

Looking east from Wetterhorn at Uncompahgre and Matterhorn

Six for One

Nearly a fourth of all Colorado 14ers lie in the San Juan range. Reaching the San Juans can involve substantial travel; hence, many climbers prefer to ascend multiple peaks in a single trip. The

San Juan 14ers fall into three geographically oriented groups: the Eastern San Juan, the Chicago Basin, and the Western San Juan. Of the three, the Eastern San Juan is the largest, comprising nearly half of the San Juan 14ers: San Luis, Wetterhorn, Uncompagre, Redcloud, Sunshine, and Handies. With good weather and a little planning, this half of the San Juan may be completed in little more than 48 hours.

High pressure settled into the Great Basin this week and the forecast opened up with a broad weather window. So I put down the back seats, threw in a mattress and some gear, and headed southwest to give this a shot.

Itinerary

Wednesday, June 16:
San Luis Peak: 3600 vertical, 13 miles

Thursday, June 17:
Wetterhorn and Uncompahgre: 6400 vertical, 20.7 miles

Friday, June 18:
Handies Peak, 2900 vertical, 7.5 miles
Redcloud and Sunshine, 4800 vertical, 12 miles

Wednesday June 16 - San Luis Peak: 3600 vertical, 13 miles RT

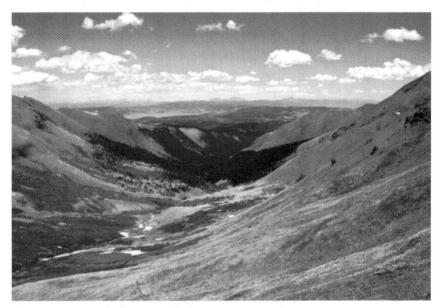

The Stewart Creek drainage, below San Luis Peak

San Luis is a long way back on dirt roads. They get a little rough at the final seven miles. Twenty miles of deserted dirt road conjure up thoughts like, do I have a good spare? What if I had to hike out for any reason? Shouldn't I be carrying a water filter? Given a vehicle failure, even after hiking 20 miles out on these roads, you'd still be pretty much nowhere. I think the nearest town this side of the TH is Saguache, or Gunnison.

But the lengthy dirt roads looked like they'd be a lot of fun on XC skis – a good possibility for one of next winter's 14ers. I arrived at the Stewart Creek TH about 10:30 and got started at 11:00 am.

Arriving at the summit at 1:40, it was too windy to enjoy lunch. The price of admission for the early part of the weather window was high winds, also part of the reason for making San Luis first up. The stream crossing lower down made for more pleasant

creek side dining. Keep your sandals on after the first crossing; the second one is a couple hundred yards up the trail. There is essentially no snow on the route right now.

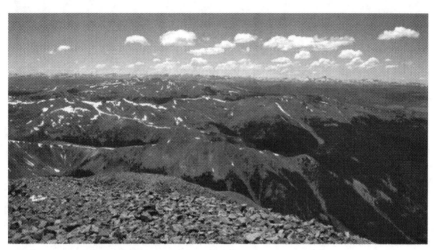

On the summit of San Luis Peak

Originally, the afternoon plan called for taking forest roads over to Lake City, though after the forest roads to Stewart creek and back, I chose pavement: 114 to 50 to 149. The scenery alone was worth the drive.

Arriving at the lower Matterhorn TH before dark, it was no trouble finding a desirable campsite. The place was deserted: one of the benefits of early season. If you made it to the lower TH, you would do fine to get to the upper TH, though flat ground is more limited at the upper TH than on the main road. I got started about six the next morning.

Thursday June 17 – Wetterhorn and Uncompahgre: 6400 vertical, 20.7 miles RT

Wetterhorn was fabulous. I had the summit to myself at 8:30 am under clear, calm skies.

Laura Janca

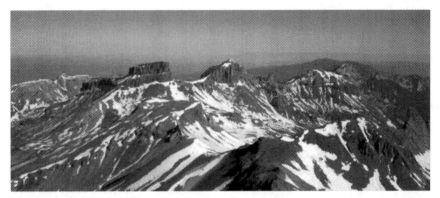

Coxcomb and Redcliff from Wetterhorn's summit

Wetterhorn's compact summit

The climbing reminded me of the San Luis Valley stuff my friend Louis used to call rhyolite. Back in the early 80's, Louis was a schoolteacher in Del Norte, and an excellent boulderer. We had the pleasure of pioneering his discovery, the Penitente Canyon climbing area, along with a friend of his from Colorado Springs. Penitente was ok, but it couldn't hold a candle to some of the stuff we found down there that ironically never got popular. The stuff climbs like granite, but can form incredible column-like flows similar to basalt. Wetterhorn's rock bore some resemblance to this stuff and took me back to the pleasant reverie of many years ago...I was like a kid in the rock garden. I particularly liked how you are moving up short, easy ledges on maybe 50 degree rock, turn the edge above, and suddenly you're on Wetterhorn's cozy summit. This is a beautiful mountain.

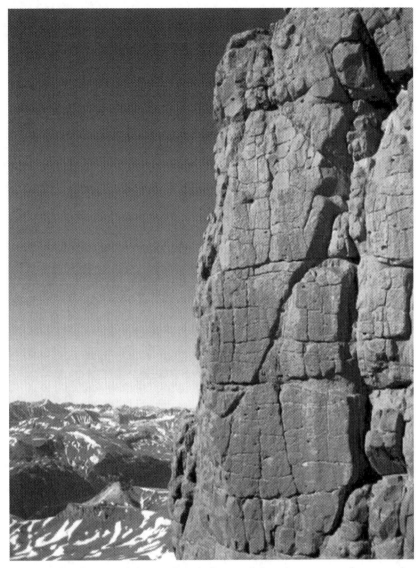

An example of some of the strikingly beautiful rock on Wetterhorn Peak

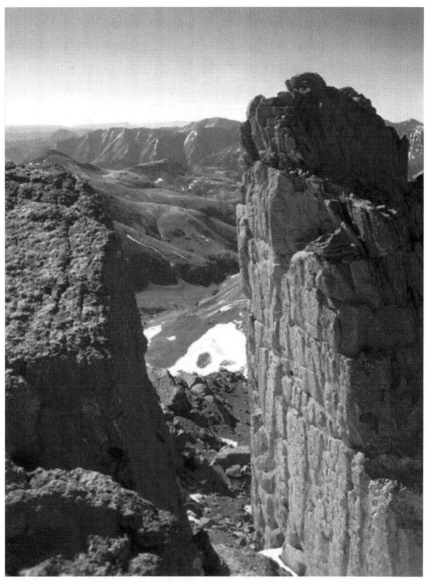

"The peak should look striking from afar..."

Laura Janca

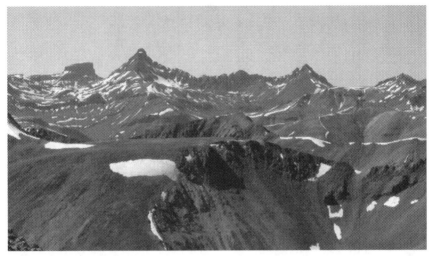

Wetterhorn from Redcloud

The snow remaining on the east aspects is easily circumvented

If you're going for both peaks, descend off of the boulder field just north of the main trail, cross the confluence of alpine runoff below, and take a high contour around the southwest facing grassy hill, staying high into the 12,458 saddle to your east. There is still some snow, but no gear is needed. The terrain is undulating, gaining and losing some vertical. Stay on the Ridge Stock Driveway Trail #233. It is marked with signs. Short-cuts are mostly futile, except for the south face of 13,320's east ridge, where a nice game trail can be found coming directly off the Uncompahgre trail at around 13,200, above.

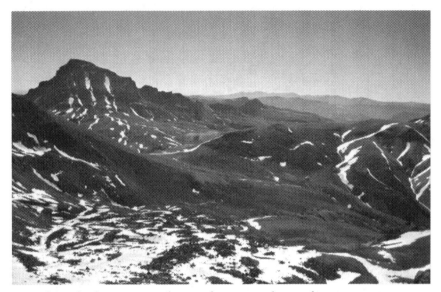

Seen from high on Wetterhorn, this view shows the connecting route between Wett & Unca. Uncompahgre is at background left, the saddle is center, Wetterhorn's boulderfield is foreground left/center.

Contrasted to the solitude on Wetterhorn, Uncompagre is festive. I must have passed a dozen folks. It's a nice mountain, and has a classic profile, but after ecstasy on Wetterhorn, it was somewhat anti-climactic.

The way back through rolling alpine hills is nice in the warm afternoon sun. Be prepared for a long haul if you do these as a combo, and make sure you have a great forecast. I arrived back at the car 11 hours later, including summit time, photos, and a leisurely lunch in the pleasant rolling terrain between the peaks. The trail to Matterhorn Peak comes directly off the main trail between Wett & Unca, in case you wanted to catch the 13er as well.

I was camped in a grassy meadow, lined with lush green aspens. Returning in the afternoon sun was so nice, it made it hard to leave. I splashed in the creek for a while and had dinner before saying goodbye to this favorite place.

The "shelf road" to Redcloud and Sunshine is not very bad. But after having quiet beauty at Matterhorn Gulch, I really didn't care to yuck it up with the boy scouts at Silver Creek that night. I found the place just a tad too urban. I made an ad-hoc motion to amend the original plan, which was immediately accepted and ratified – one of the easier facets of traveling solo – and was soon off to discover just how bad the road is over to American Basin. Three and one-half miles took nearly half an hour. The stream crossing looked easy, but it seems I'd recalled someone saying it's tougher than it looks, and it was getting dark, so I parked in the pull off. Two hours later I awoke to clawing noises coming from under the car. Every time I tried to forget about it and doze off, it would start again and wake me up. By midnight, I was certain it was eating wires and I'd be stranded – or that it was trying to get at the food smells and was clawing its way through the air ducts. The boy scouts really would have been better after all. I got up and moved the car a few hundred feet back down the road to a level spot. No more clawing, and sound sleep at last. The car even started.

Friday June 18:
Handies Peak, 2900 vertical, 7.5 miles
Redcloud and Sunshine, 4800 vertical, 12 miles

The 6:00 am start found an easy mile to the upper TH, but at that point it didn't make sense to go back for the car. If you got to the stream crossing, you should be able to cross it (this time of year) and get to the upper TH. If you choose to hoof it, the stream crossing is bridged to the left with a huge drift which should be around for a while. It's quite solid to walk on.

American Basin is not quite as pretty without all the wildflowers. The trail is easy to lose where it crosses from the west drainage to the east drainage, but one would have to work pretty hard to get lost in this tight cirque. Not surprisingly, Sloan Lake, at close to 13,000 feet, is still frozen. Between the lake and the saddle, there are a few north facing snow-filled gullies to cross. One in

particular has some runout. The snow is firm and crunchy in the morning, with good kicked in steps. One of the more intelligent decisions of the day was to leave the axe in the car. Fortunately, there is a way around the main gulley, though it would be better to just have the axe.

If you want to party with your friends, you can either go down to the corner bar, or go climb a 14er. Right on schedule, at 8:00 am sharp, Shredthegnar10 and I arrived at the summit simultaneously – she from Grizzly Gulch, I from American Basin. I feel a little embarrassed that I talked so much. Guess it was all the solo time the prior two days. Maybe I should have stayed on her side of the hill last night. I'm thinking the boy scouts are starting to ~~look~~ pretty intelligent.

Well, more peaks were waiting, time to get down. The first hints of that pulled muscle from rock climbing Tuesday night blossomed into full tilt knee pain on the Handies descent. There was minimal pain with uphill travel, but extreme pain with descending. I could barely hobble to the car. Redcloud and Sunshine looked pretty much out of the question at this point, so I was about to call it at four peaks and go home.

On the way back to the Redcloud TH, about 11:00 am, I found myself making a half-hearted effort to repack, and started down the trail at 11:30 with serious doubts as to my sanity. I couldn't imagine how on earth I was going to descend 4800 verts in this condition, particularly after just doing 2900 verts earlier that morning. There was only another 12 miles to go. I was lamenting breaking my rule about not doing much of anything the night before a big climbing trip. I threw in a roll of duct tape to lash the poles to the knee just in case, but left the headlamp in the car. I really didn't expect to get very far. Food check: one cookie and two granola bars. I'm not really going to attempt this, am I? The only half intelligent thing I did was to pack three liters of water. It was a hot summer's afternoon in the San Juan.

Two miles up the trail, I'm ready to turn back. Sandalot recognizes me from past Trip Reports. I can't thank him enough for diagnosing the knee problem and encouraging me to get those last two peaks. After nearly twenty minutes that seem more like a reunion of lost brothers than a chance meeting, he realizes I'm stalling and won't let me get away with it. Bless his heart; without his encouragement I'd probably have turned back. He even offered some Advil. Hey Sandalot, thanks, and best wishes on your Capitol Peak and Snowmass attempts next month.

Right after our chance meeting things got better – the scree disappeared and turned into rolling hills of tundra in an asthetic rounding cirque with classic alpine switchbacks to a saddle, looking more like Switzerland than Colorado. The knee pain was only on the occasional downhill dip during the ascent – but I knew I was racking up quite a payback with every vertical foot of gain. The plan was to worry about it after getting these last two summits.

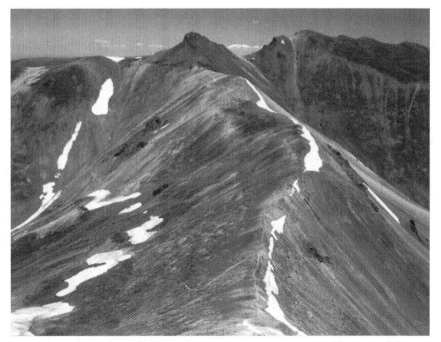

The saddle en route to Redcloud Peak. Strawberry Scree Fields ... Forever

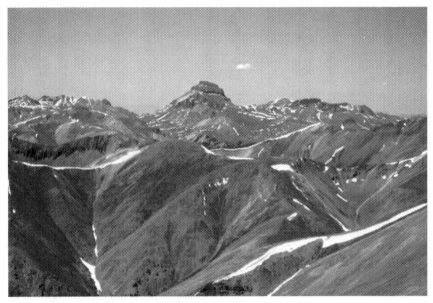

Uncompahgre
"So many fantastic colors; makes me feel so good..."

Redcloud and Sunshine are reminiscent of a monster Belford and Oxford. Bel/Ox is 6000 vertical feet and 11 miles; Red/Sun is only 4800 verts and 12 miles, but feels like a much grander scale. Perhaps it was the knee. That three-mile stride out and back to Sunshine was murder.

Two hours and forty minutes to Redcloud, check. Two more hours out and back to Sunshine, not bad considering. Three hours to limp my way back down, ouch! If I weren't the only one up there at that late hour I'd have looked pretty funny with that hiking-pole-crutch-gait thing going on. But the weather was holding in what appears to be one of the best, broadest summer weather windows in quite some time. I hope this trip report is one tiny speck in a flurry of great reports from all you guys and gals during this great early summer weather.

Wildflowers on Redcloud

Aspen leaves glowing in the afternoon sun

I can't believe I'm back at the car by 7:00 pm. Trashed, but immensely satisfied. The first order of business is to toss all the gear into the back and assemble all the finger foods and several bottles of water on the passenger seat. After a quick douse in the stream and a change of clothes, I'm headed down the long road home, really happy to have six more in the bag, and nearly half the San Juan down in one short trip. That puts a smile on my face as big as the western sunset.

Mt. Sneffels in Winter:
East Ridge Direct via Lavender Couloir

Date: March 14, 2013
Approach: Yankee Boy Basin from Revenue Mine
Length: ~8 miles RT
Vertical: ~3700 feet
Ascent Party: Dancesatmoonrise

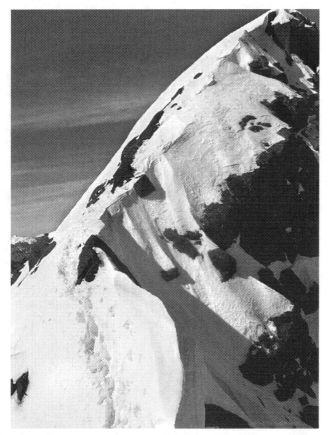

Looking back to the summit of Mt. Sneffels from near the top of the East Ridge.

Mt. Sneffels' East Ridge is short, but sweet. In summer it makes a nice rock scramble. In winter, the start out of the top of the Lavender Couloir presents an interesting mixed line.

On Thursday, March 14, 2013, the second day of a high pressure warming trend would bring some of the warmest winter temps seen to date. An early start would be helpful to get off the mountain before the potential development of wet slides. Making the mistake of staying in the car on the Camp Bird road (CR361) I didn't get much sleep. The mine traffic actually runs, if sparsely, most of the night. One might have guessed this. The saving grace was finding the gate open in the morning, which knocked off three miles one way, helping make up for an otherwise late start.

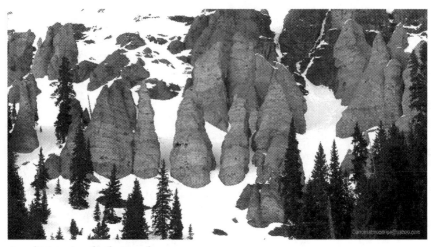

Good Morning little Hoodoo.

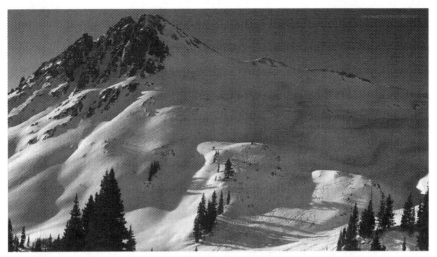

Stony Mountain: The heli-skiers apparently feel north and east aspects are stable.

Laura Janca

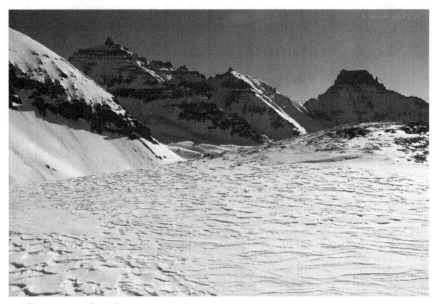

Wall street, Colorado.

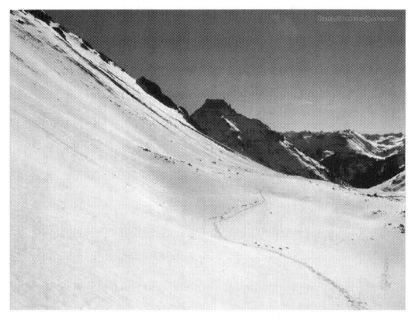

Flirtatious.

Careful where you step.
I'm sure all this happened yesterday. ("Roller balls and a wet snow surface
are good indications that wet slides are imminent." -CAIC, North San Juan
Zone forecast, 3-14-13.)

Coming up out of Yankee Boy Basin, which is at top right in the photo above, I make for the bare area at the right side of the upper face (top center in photo above.) From here, around to the north side of the saddle (top left in the photo above,) to gain entrance to the couloir. There are a number of roller balls on the face, many off of the steep rock outcrops, and some point releases, though these appear to have happened yesterday. Not a thing is moving so far this morning. I'm hoping it stays that way by the time I pass through on the descent.

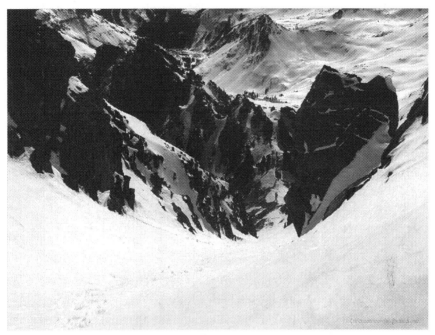

The upper Lavender Couloir is a beautiful thing in stable snow.

Finally at the top of the couloir, I look over the saddle and stare down the Snake Couloir. I'm still amazed me that people ski this line.

Looking left, I see no reasonable, safe way across the steep rock and snow that I'm comfortable with. Looking directly up, there's some steep rock for about 20 feet, which appears to top out. It's been about three years since I was up here; I recall the summit being very close to the top of the couloir. I'm sure the flatter area at the top of this 20-foot climb must be the summit. The climbing looks technically harder here than going left, but the rock looks good, and well-featured, whereas traversing left goes onto some thin snow over steep rock, which can be tricky. I opt for the more technical line, straight up the steep corner of the ridge.

The moves are interesting, and somewhat exposed. I've been on 5.7 rock routes that felt about like this. I'm able to get solid hand placements all the way, though I'm nervous, brushing snow and

exposing holds, hoping that in just a few feet I'll be on the summit. I try to put out of my mind just how I'm going to down climb this section. Perhaps I'll see an easier way around once on top.

As I top out, I'm appalled to see that I'm on a coffee-table sized pedestal, looking at a down climb ahead and behind. The summit is further up the ridge line. The sole saving grace is plenty of snow on this pedestal to sink the axe. I get a solid axe plant and have a look at the down climb on the far side. Nothing much to do but continue on at this point. The climb down the far side is not as bad as what I just came up, which still haunts at the back of the mind, knowing it's coming up on the descent. No matter, the true summit is just ahead. We'll worry about that first.

The rest of the ridge is interesting. Steep snow and rock to the left, a cornice on the short ridge section just ahead, and a very steep drop to the right. As I cross the ridge, I'm testing each new foot placement in the snow to make sure it's not bridging a gap between rocks. Falling through a snow bridge is not an uncommon fate in the life of an alpinist. I think of the almost legendary image of an old fox walking carefully across the ice on a lake. The axe makes an excellent sounding device for solid rock below. Thrusting to the right, I hope it's not poking into air on the other side of the cornice.

Sometimes it's hard to know the exact best line across a corniced ridge. Too far below the ridge, and one looses the advantage which is conferred by the ridge against avalanche. Too close to the cornice, and one could knock it off, or pop through. All the while, like Tuco in the noose staring at the gold at his feet, I gaze at the summit, now a mere 80 feet away. I pick my best line. The snow is solid and kicks great steps, while the axe is busy sounding out the depths. In a moment, the summit is mine.

What a fleeting feeling. The summit is not something we may hold long. And it is something which must soon be relinquished to an often long and not infrequently dangerous descent. It is interesting that we place so much human importance on attaining the summit. For truly, is it not the memory of the beauty along

the way, both the visual, and the beauty of the vertical dance, that lingers, so much more durably, in the memory?

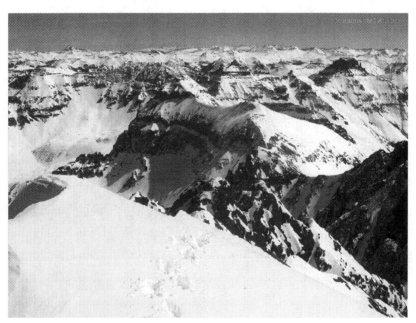

The views are pretty. Hope the floor is solid.

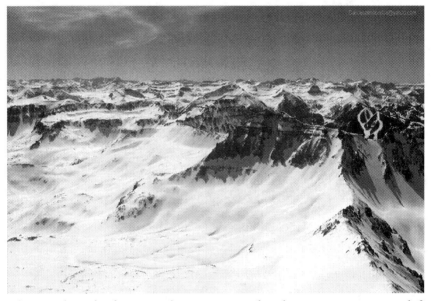

Gilpin Peak in the foreground. You can see the Chicago Basin 14ers at left skyline. Telluride to the right.

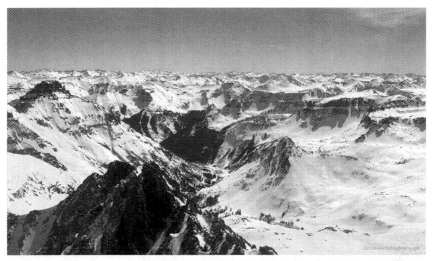

Looking down-basin. Kismet Mtn. in the foreground; Chicago Basin group at right skyline.

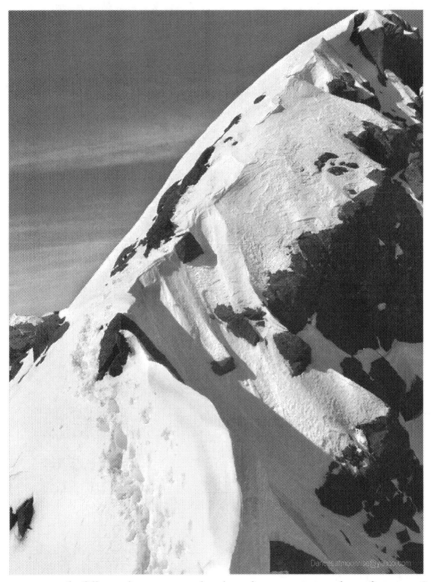

But seriously folks...What can you do when the summit is only 50 feet away?

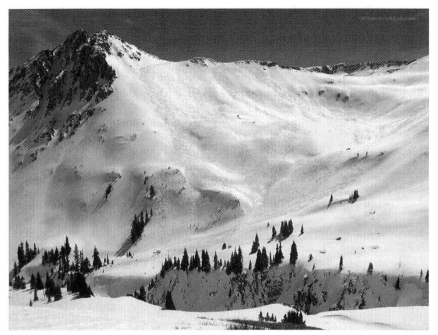

The helicopter crew has been busy today.

The remainder of the slog back goes without incident. On the way out, I begin to understand the issue over the road. Some of the rock here is quite interesting. Since I was here last, a number of routes have gone up, and it looks like several hard projects currently being worked.

I'm glad to be off steep snow well before the mid-afternoon heat. It's an incredible, warm, spring-like day on the western slope. I spend a few minutes organizing things at the car, head into Montrose for supplies, and continue on to the Cataract Gulch TH outside Lake City, where I'll be meeting Ted tonight, for a planned attempt on Handies in the morning via Boulder Gulch.

Thanks for reading, and hoping the report has been entertaining, and proves helpful for those interested in making a winter attempt of Mt. Sneffels.

It's Not About the Bike:
A Winter's Day on Mt. Lindsey

Peak: Mt. Lindsey
Route: NW Ridge
Date: January 9, 2013
Length: 22 miles
Vertical: 5400 feet
Ascent time: 7.5 hours
Ascent Party: Dancesatmoonrise

There's nothing after Gardner, Colorado. Or, not much. A few rural households here and there along the road, then a long stretch back to a state wildlife area, followed by a couple of vacant ranches. It's a timeless, ethereal drive in the early morning winter darkness.

Why would anyone want to seek high mountains in winter? Summer is lush, colorful, warm, wet, pleasant, alive. Winter is cold and harsh; a canvas of colorless greys. Yet, the harshness of winter can evoke a quiet beauty. To experience the mountain when everything is at rest in tacit winter repose can be truly magnificent; even more so for those willing to journey into the profound quiet alone.

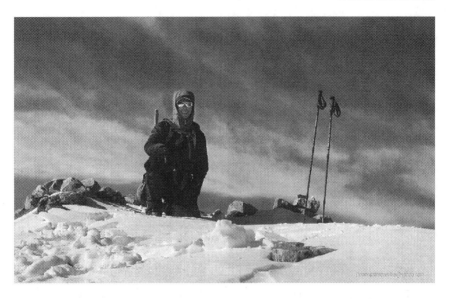

Great Experiments in Tele Racing?

A long time ago, Tele skiing was in the dark ages. I went to a race in Utah. The only real Tele boot then was the Asolo Extreme; it was all-leather.

So those Utah guys were building their own. The favored technique was pickle barrels. You'd cut out pickle barrel plastic, affix alpine latches, and put the thing around your leather boots. It was really kind of comical. As a joke, after one of her big wins, Kate Hasterlik wrote, "Thank you, Vlasic!" on the back of her white pickle-barrel boots. It wasn't long before we were beefing up the soles in the lateral plane so they would carve... but back to the pickle barrels.

Voile (Wally, in Utah, whom they affectionately called "Voll-eh,") had just started manufacturing releasable Tele bindings. I knew about them, but figured after a million cartwheels, I didn't need releasables. That was before plastic. Hooked a gate. Six surgeries, and more than a year later, thanks to the boys at Lakewood Orthopedic, I was walking again. Even running gates again a couple years later. But back to the bike...

A Life-long Love Affair.

Still in a post-op cast, Tommy Carr, one of the Tele racers, told me about this new thing called a mountain bike. The Fisher Montare was about the only thing around then. Goofy looking by today's standards, it got you into the mountains. I was still on crutches, but now, for the first time in months, I could break a personal speed record of 0.5 miles per hour. I was in love. God Bless the Bike!

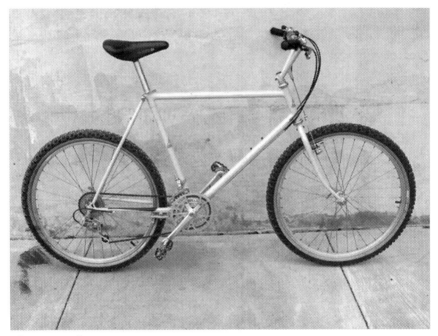

The 1985 Fisher Montare

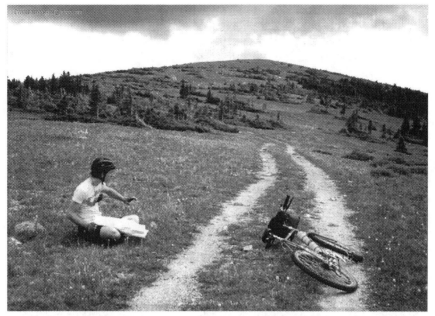

Early alpine orienteering, high above Winter Park, Colorado, with the Fisher Montare.

The Fisher Montare was rigid front and rear. There wasn't much on the bike to go wrong. I no longer have the Montare, but the 1987 Ross Schaffer hand-built Salsa, raced in the Colorado Off-Road Series and the first unified Mountain Bike World Championships, still occupies the old bike stable.
It sports original SunTour XC Pro components from the 1989 race season. Of course, nowadays that stuff belongs in museums. Fortunately, I myself have escaped such a fate. At least for the moment.

I still adore the bike, riding for fitness and enjoyment every day, all year long. At least, every day I'm not on a mountain.
Speaking of which, back to mountains...

Fear and Soloing on Winter 14ers
Winter comes this year, and I'm not feeling very motivated for 14ers. It's probably because after the first three dozen, the winter 14ers start to get scary. It's hard to find skilled, interested partners outside the few that are already tight with their own partners. I remember (stupidly) turning down the opportunity to partner with Steve on North Eolus. I didn't feel I was experienced enough, but it would have been a huge step forward.
Steve's such a great guy, I'm sure if I'd said yes, I'd be up 4 Chicago Basin 14ers right now. (Or dead, not sure which...)

But what really gets my respect is the fact that both times Steve is looking for partners for Chicago Basin, and can't find any, he goes solo. The guy's got balls. I can only say that I've experienced in some small part, the joy and self-satisfaction that comes from a good solo winter trip.
Like Steve, I prefer partners. And like Steve, if I can't find qualified partners, I'll go solo. Only, I think I may worry more than Steve. God knows I can't sleep before a serious winter solo attempt, but on the other hand, once the feet are on the ground, all of that disappears, and becomes a joy, a satisfaction, a communion with Earth; a microcosm of its own, devoid of the cares and concerns of our day to day reality:
A joy which any of us has the ability to experience, given the courage to go forth into the quiet.

Biking a 14er in Winter?
In the wake of a successful Longs winter attempt on January 4, 2013, the warm weather continues into the following Wednesday. It would be frankly criminal to waste a windless winter day in the alpine with minimal avalanche danger. Lindsey is one of the few easier ones remaining; a long daytrip for sure, but doable. Friends are headed for Redcloud/Sunshine, which I "need." But it's been too long since wading the baptismal waters in personal confirmation of solo communion on a winter 14er. I need to go see God.

Just for the record, some folks ask if being that far back, alone, without a phone, or a GPS, or a spot device, is scary. Well, yes. But more so the day before the trip. I pick up the phone and call Paul for beta, since his group was in there last month. I'm totally bummed to learn he had to carry skis most of the way up the road. I can barely ski those sticks any more, much less carry them. OK, that's out. Maybe this whole trip is out. Twenty-two miles round trip, a fourth class ridge, solo, winter, parking nearly a mile below the Singing River Ranch due to private property? Screw it. I'm out.

Twenty minutes later I'm tossing everything in the car. What about the bike? Certainly, the bike is larger than a cell phone, but it's smaller than a Honda Pilot hopelessly stuck in the snow. Under extreme duress, it could be the only taxi back to Gardner. Sure. Throw it in.

I hit the hay and try to get four hours of sleep. I'm awake before the alarm.

Dawn on the 580 Forest Road to Mt. Lindsey.

The drive to Walsenburg is a breeze at 4 am. Deputy Joe Albano of Gardner (absolutely great guy, by the way) assures me there are no issues if one parks below the SRR. Deputy Albano has my name, plates, and vehicle description, and he's on SAR. I let him know I have no intention whatsoever of using his services. We share a laugh. These are good folks.

A warm day is forecast, belying the 6 degree pre-dawn chill in the drainage. I drive to the SRR anyway, to see if I can pass, and recall Paul's admonitions that Matt and crew had to drive backwards quite some distance to end up parking below the ranch. I head back down and park at the end of the wildlife area, at the pull-out on the west side, about 0.8 miles below the ranch. It's 6:30 am. I've got boots, snowshoes, skis, a bike, a sleeping bag, and no clear plan. Still half asleep, I look at the road, scratch my head, and pull out the bike. I tentatively put the pack on, mount the bike, and try a little riding on the snow. I'm sure they must do this in Alaska. And maybe Crested Butte.

Before long, I'm riding a bicycle on a snow-packed road somewhere in Huerfano County in the middle of the night in January. You pretty much have to be not right to even consider doing winter 14ers.

Lindsey's Winter Route.
There's presumably a caretaker for the lower of the two ranches, though the sole dim light illuminating a building in the distance off the road in the pre-dawn night discerns no human activity. I find it odd to be approaching a winter 14er by bike. The air is crisp; the darkness, hushed.

In surprisingly little time, the Aspen River Ranch appears in the darkness to my left. The road in remains snow-packed. Studded Nokian snow tires continue to grip, the full suspension carbon

fiber 29er still wants to dig in and move forward. I ride the carbon pony into daybreak.

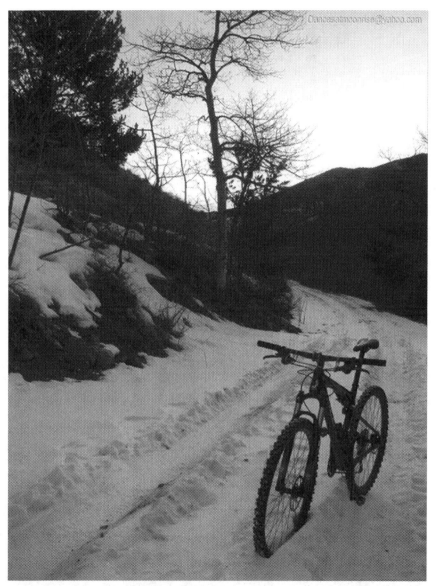

Easy to get unstuck when it high-centers.

Paul's beta is spot-on. Many dry hills after the last ranch make a perfect day's ride by any measure. The bike rules, making quick time till a mile from the forest boundary, where the snow is just too much for even a Pugsley. Fair enough, time to derail this horsing around and get to business. It's intermittent post holing for the next few miles to the summer TH, where I give it up and plug feet into these unwieldy bear traps they euphemistically call snowshoes.

It's a gorgeous day, and a beautiful sojourn into pristine winter wilderness.

My predecessors' tracks have long ago evaporated in the new Christmas snow which followed their successful ascent. Luckily, a sole unsung hero has since gone in on skis. Not a great track, but most helpful for route-finding, until the secret sharer decides to turn back.

Blanca.

There are two tricky route-finding problems in winter. The first is finding the correct spot at which to turn left, up the drainage into the alpine. One locates the drainage by finding the huge rock wall to the left, beyond which is a treed, moderate slope. Between these is a break, which lets in the morning sun: this is the spot. If one is on or near the summer trail, a boulder field is encountered early on. The summer trail traverses below the boulders into steep trees, still south of the gully proper. When the slope angle backs off, one moves into the gully.

The break in the drainage is just beyond the first rock wall.

The snow below the boulders is crapola, a technical term for "would be scary if steeper." Put another way, snow depth is 6" greater than the snowpack.

That last half foot provides no resistance to the Joe-six-pack pole-thrust technique, a quick and dirty method utilized when one

lacks the technical savvy to waste time digging a snow pit. In the trees, the snowpack feels a lot better.

On course.

The other route-finding issue comes in the alpine. In summer, with a trail and cairns and a route description, it's no issue. Map and compass provide a sort of surrogate vision of the high peaks which is lacking in the lower alpine basin due to the surrounding hills, as the guidance previously afforded by my unknown ski-peer is now a thing of the late morning passed.

Speaking of which, I need to summit by 2:00 or 2:30 to get down through the sketchy sections in daylight. There is an area of concern within the steeps in the trees and transition to the gully. Better upshift into high if this effort is going to be successful.

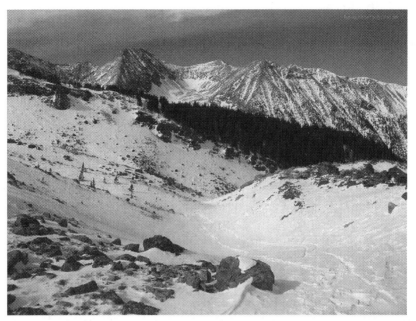

Upper gully.

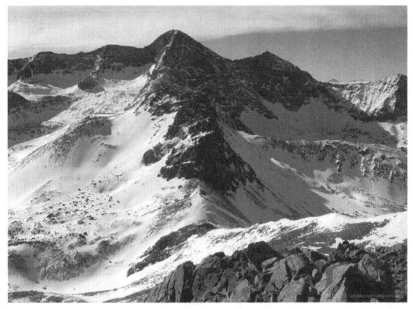

The Gash.

Matt's TR is my first introduction to the NW ridge having a "down-climb crux." Taking the trail to the ridge in summer, one does not encounter this, and given low snow, it can be avoided in winter as well. But as with most alpine ridges, the ridge proper is more stable (less loose rock) than anything on the face below. Besides, I'm curious. Thus it happens that I encounter the Grabina Crux.

Exposure.

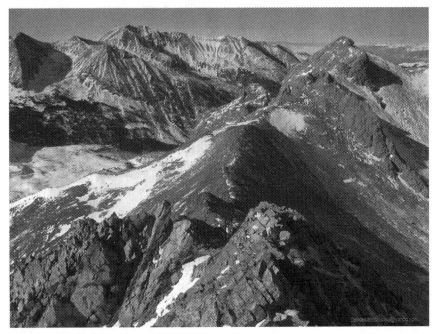

Looking back down the ridge.

I keep firmly in mind the balance between speed, the desire for the summit, and caution. Things go well. Yet, Lindsey is a mountain which apparently enjoys sharing its sense of humor with its patrons. After all that crux stuff, here we are, standing on a false summit, out of time.

I smile, having forgotten about this false summit. Three headlamps with spare batteries quietly whisper to just keep on going.

Mt Lindsey's summit in winter.

Crestones, anyone?

Somehow, I'm leaving the true summit by 2:30 pm. Is there really a bike ride waiting down there somewhere? The down-climb goes without a hitch, though with plenty of caution. The avy area is still in daylight and goes well.

Now at the bottom, the drainage floor is phenomenally beautiful at dusk. Memories of summer crash gently in the fading light, like massless waves of surf against my consciousness. I want mid-summer, a flyrod, a blonde, some beers, and a nearby tent. Admittedly, the hallucinations are more complex than the standard dead-tired post-slog mirage of cheeseburgers, but the syndrome is familiar. It's almost completely dark. Ah, the summer trailhead. Enough stubbornness. I can barely see anything on this moonless night. Let's give it up and get out the headlamp.

From here, the view never changes: A big ball of light, a snow-packed road, a track up the middle. You know the drill. You're dead sure you missed some important turnoff in the darkness. You almost turn back to check. You carefully verify that the tracks you're following are your own.
Satisfied for the moment, you continue. Only to question again in five minutes. This goes on, of course, for miles.

Ah, finally, the tracks of a familiar friend. Unless some insane person rode a bike up here... Oh, wait. Nevermind.

Soon the waffle irons trade out for wheels, scrubbing 3-4 miles off in a matter of minutes, sitting on my butt. A sub-alpine glissade. That's the way you do it. Why didn't I think of this?

The headlamp does a fine job illuminating the road ahead. Before long the Aspen River Ranch passes on the right, then the Singing River Ranch.
The road gets faster and easier. Soon the car appears. All told, about two-thirds of the route is done by traditional means; one-third by bike.

So good to be at the car. I dig into the cooler for a beer, pull the wheels off and wipe down the bike, start packing up, and begin to muse:
How much snow do you suppose is on the standard Stewart Creek TH approach to San Luis right now? Is it possible that.... I mean, I've always wanted to go that way, just because... Nah. No way...

But really, it's not about the bike.

Other Side of the Calendar:
Baldy Alto by Bike, Summer Approach

Peak: Baldy Alto
Route: Nutras/Stewart Ridge
Approach: Dome Lakes (FR 794)
Date: January 23, 2013
Length: 28 miles
Vertical: 4300 feet
Ascent time: 8.5 hours
Total time: 15 hours
Ascent Party: Dancesatmoonrise

Morning glow graces Baldy Alto and Stewart Peak.

Ever since driving the 794 Forest Road from Dome Lakes to the Stewart Creek TH in June 2010, the thought of cross-country skiing the 53 miles in to San Luis Peak becons. With mostly rolling hills, it seems doable, though would make for a long day. The idea is naturally relegated to the back burner...

January 18, 2013. I'm driving over to the Mill Gulch TH, to join Teddy and the guys for Redcloud and Sunshine. Somewhere after Monarch Pass, the light bulb suddenly goes on: heck, it's Friday, and all I'm doing is car camping at Mill Gulch tonight. Plenty of time for a quick 50 mile detour.

The road down to Cochetopa and the Dome Lakes area is quiet and pleasant. Chains, shovel, ropes, and tarp, are standard winter-issue

for the vehicle of any winter-14er enthusiast, but I don't want to blow the Redcloud/Sunshine trip spending tomorrow digging snow, so I take it conservatively.

Getting back onto the 794 road, I'm pleasantly surprised to find low enough snow to get 6.5 miles in. This knocks 13 miles off the potential 53 mile RT to San Luis. Sure, 40 miles is still long, but it's starting to sound more feasible. And I'm sure the car will get a couple miles further in. I'm off to Mill Gulch, quietly enthusiastic, project preview in my back pocket.

Wednesday is the last day of this nice 10-day run of good weather and some of the most reasonable avalanche conditions this year to date.

Ah... Wednesdays. Mid-week. Perfect. The lusty thought of stealing away unnoticed between the busy boulevards of the workaday world to quietly emerge in the backcountry... it's too much to resist. When business is poor, the poor get down to business. Never mind the backlog; it's winter. Work is for days of sideways snow and people who don't know how to fly fish; as the expression goes. OK, back to business...

Tuesday, January 22, 2013. Tuesday is supposed to be car-camp day, but phone calls, faxes, and fires to put out abound. I manage to get out to Dome Lakes, drive in about 8.5 miles (as far as I dare) and get to bed shortly after midnight.

Originally, the idea is to ride the bike back as far as possible on Tuesday, then come back to the car to camp. This way, it would be clear whether skis or bike would be better – I have both in the car. But given the way my Tuesday goes, I make a rather stubborn administrative decision. I know skis would likely be more efficient, but I feel more like riding the bike. The bike it is.

No kickstand required. Not as deep for 29" wheels.

First light comes too soon. Fortunately, winter is now in full swing and I remember the trick of burying a thermos of coffee deep within a down jacket, all in a stuff sack. So there is coffee. And soon thereafter, intelligent life.

Seems no matter what the forecast, starting the TH this winter clocks in at a balmy 2 degrees above. The Shimano juice brakes run on mineral oil – a great idea if you live in Japan. In Colorado winter, you loose all modulation at these temps. No matter, we'll be on the pedals more than the brakes this morning.

I'm lucky that my predecessor decides to chain up and drive back as far as he or she could. How far back? Don't know yet, but as long as the bike stays in the track, the going isn't bad. Progress seems to move along at a great clip, but the map doesn't seem to want to cooperate.

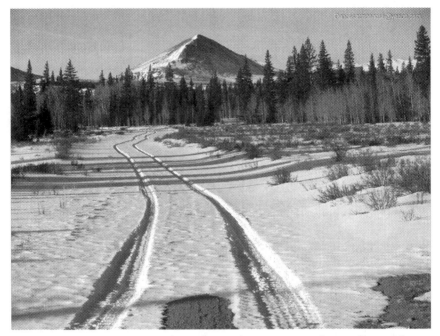

The lens is more generous than the trail: Stewart Peak is still 11 miles in the distance.

Shouldn't complain; got a track, right? Oops, complained too much – here's the end of the line. Time for snowshoes. I stash the bike, change out to boots and bear traps, and start the long plod.

What's this? Stewart Creek summer trailhead 6 miles? Oh joy. A quarter mile later the sign says 5 miles. Let's hope this keeps up.

Finally at Nutras Creek, I make the decision to go in here. It should cut 4 miles RT, not having to go all the way to the Stewart Cr TH, plus the route up Nutras should be 1 mile RT shorter than the Stewart Creek route. That brings calculations down to somewhere around 30 miles round trip.

The thought is, knocking 5 miles round-trip off the route is significant. Still, it is unknown which route may be more efficient, as there could be less snow-breaking up the south-facing aspect of

Stewart Creek. No matter, I'm tired of this road; time for some new scenery up the drainage. Besides, the idea of trying this new route sounds appealing.

Route planning calls for taking the second bump to the left. The first is 11,400. The second bump constricts the drainage; it's easy to tell where to hang a left. Unfortunately, the trees are thick with snow. One would think it's winter or something. Trail breaking takes its toll.

Soon the mellow ridge between the Stewart and Nutras Creek drainages makes it difficult to tell which way is up. I follow the compass, and lean toward the south side. A warm day is nice, but south side snow is thick and goopy. Soon my snowshoes weigh about 10 pounds each. Back to the trees and downed timber of the north side. Why did these hardy trees decide to grow all the way to 12,000 on my ridge, anyway?

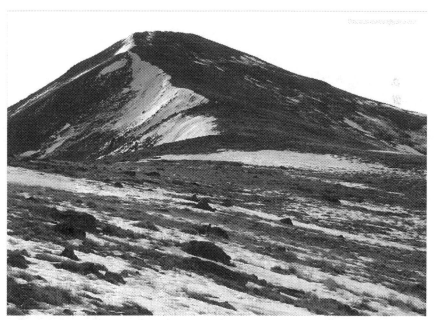

Baldy Alto.

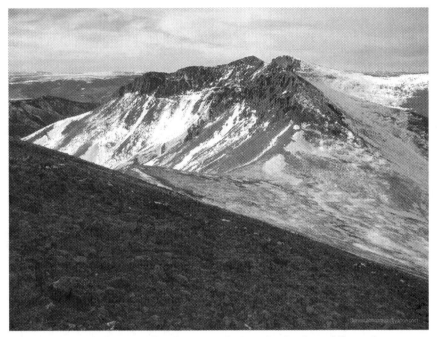

Extra credit: "Column Ridge" 13,795, shares the high saddle with Stewart Peak, unseen at right.

At the Baldy Alto summit, more than beat from six or eight miles of continuous trenching, I'm half-dead, but sure I can get San Luis – but not sure I can get back at a reasonable hour. I've started carrying a stove, which will surely come in handy today to melt some snow. Prudence would suggest paying respects and turning back here. Even if you don't care much for Prudence, it's best to listen to her; she'll kick your ass if you're not careful.

Besides, I've got a couple of friends waiting for an email when I get home – if it's not there by 6 am, I'll have the embarrassment of Search and Rescue to motivate me. Some quick calculations suggest getting San Luis would put me on the ragged edge of that 6 am home-time. Mountaineering would be nothing without desire. Especially the desire of summits unattained. I feel like Arnold. "I'll be back." OK, let's get out of here, and hurry up.

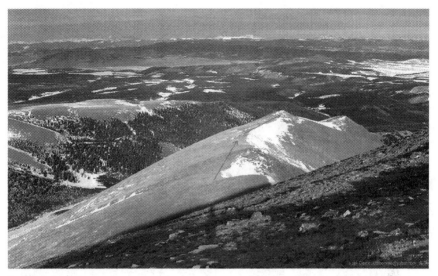

Long way home.

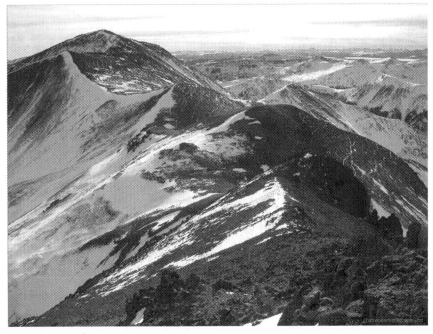

San Luis: so close.

At the corner of Nutras and 794, I stop to cook some snow. It's a long process, but gets an extra liter in me. Still not enough. Slogging along 794 in the dark, I can't believe I finally get to the bike. Problem is, this ride is hard. The downhills keep things going and keep the front wheel in the track.
The occasional uphill is difficult. My erstwhile equine enigma bucks me off a few times. Makes it tougher with a pack. Gotta loosen up those new pedals next time I think of it.

Soon I realize I don't have the necessary energy to pilot this pony. Pushing is not such a good idea – you're either walking in deep snow next to the track, or pushing the bike in deep snow. No help for it. I do my best to ride. There is good news. There is no doubt that San Luis was not in the cards today. Today being defined as the day that ends in a couple hours when the clock strikes midnight. Maybe with a little luck I can be back and take advantage of my trench before the next big storm.

Soon I'm at the car. Another red-eye express home. I pull in to one of my favorite campgrounds along the way, fall asleep in the front seat, and awaken refreshed. The clock says I've only slept 15 minutes. Amazing how much it can help. I get home, get the necessary emails out, and crash.

Ah, sweet winter sleep, and dreams of a quiet journey, far far away, in a place seldom traveled under January moonlight...

Secrets of Gray Needle and Other Stories: Five Days in the Weminuche Wilderness

Peaks: Sunlight Spire, Noname Needle, Grey Needle
Dates: August 18 through 22, 2012
Climbers: Sgladbach, Dancesatmoonrise

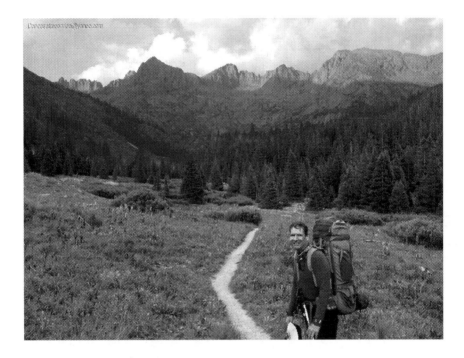

A few words about Sunlight Spire

Sunlight Spire is the name given to this beautiful, steep crack line culminating on a compact summit near 14,000 feet. The origin of the name likely represents its use by alpine climbers through the years. The Spire is not officially named by the USGS.

About five or six years ago, the USGS resurveyed a number of peaks. On average, the majority of peaks gained about seven feet of elevation, including peaks in the San Juan range. Some alpinists have therefore conjectured that Sunlight Spire, with a surveyed elevation of 13995 prior to the resurvey, may in fact now be a 14er. If so, it is both officially un-named, and unranked. Sunlight Spire has about 200 feet of prominence. In other words, the vertical drop between the Spire and nearby 14er Sunlight Peak, is about 200 feet. By convention, a minimum of 300 feet of prominence is required to consider a peak as ranked. Still, there are those that feel Sunlight Spire is, or should be, the "60th fourteener." Or the 59th, if one does not count North Massive. Mostly, though, the appeal of the Spire to alpine climbers is its gorgeous hand/finger crack splitting a clean, overhanging face, culminating in a compact summit near 14,000 feet.

A few words about Gray Needle

Not much is known about Gray Needle. It's a ranked 13er along the Jagged Mountain ridgeline, at 13,430, along with Noname Needle, 13,620. Many long-time Colorado mountaineers know of no one who has definitively climbed this peak. There reportedly exists a 1954 American Alpine Club journal entry documenting a 1953 ascent during which the ascent party utilized expansion bolts for a 30-foot section on the summit block, presumably a bolt ladder for direct aid. It is uncertain that Gray Needle was actually the peak which was climbed. If the 1953 ascent party actually climbed the peak, it still remains uncertain whether Gray Needle has yet to see a first free ascent.

Steve Gladbach is among the few that have climbed all the ranked, named 13ers. He was also the fourth, and last (as of this writing,) to climb all of Colorado's 14ers in calendar winter. A current goal for Steve is to continue with the ranked, un-named (by USGS) peaks above 13,000 feet. Gray Needle thus represents a sizeable challenge within this category.

And a little Personal History

I first saw Sunlight Spire in 2010, on a trip to the Chicago Basin, to climb the four 14ers there. As soon as we saw it, my partner and I knew we wanted it. However, we did not have technical gear with us, and due to his work schedule, only had two days to hike the 42 mile round-trip from Purgatory TH and make the 12 hour round-trip drive. I knew I'd be back.

Last month Roger, John, Britt, and Steve had planned to go in for Jagged Mountain. We were hoping to add Sunlight Spire. Schedules, logistics, and, ultimately, weather, precluded any reasonable consideration for the Spire on that trip. Steve offered a block of time during the last half of August.

GFS models were less than perfect, suggesting rain on our first day into the Chicago Basin (Saturday the 18th,) a possibly good day for the Spire on Sunday, a completely socked in day on Monday, a completely clear day on Tuesday, with rain returning before Noon on Wednesday. I really wanted to see high pressure parked over the Great Basin for this trip. Two days before leaving, Steve offered the option that we go as planned, or go in October, or give it a shot next year. Turns out the models were remarkably accurate, even if they spared us from storm on our first day in.

Getting There

We met in Silverton at 2:00 pm, and took the 2:45 train to the Needleton drop-off, with the idea that we'd make a Chicago Basin camp before dark. The train was running 30 minutes behind schedule. We hoofed it and still made the Basin in plenty of time to set up camp before last light.

The late train should still get you into Chicago Basin before sundown.

Many idyllic camp sites are easily found in the still-pristine Chicago Basin.

Approach

We broke camp Sunday morning and moved packs up to Twin Lakes. We decided to suspend the packs from overhanging rock. Steve found a sizeable rock to tie a line to, which worked well. The goats, marmots, and other critters either couldn't get the packs, or didn't care to. Up to the Spire we headed, with "a rope, a rack, and the shirt on my back" as the old saying goes. Well, we had a few emergency supplies, too.

To gain the base of the Spire, take the standard trail to Sunlight Peak. It was upgraded about two years ago by the CFI, and is in much better shape now, though the last couple hundred verts before the saddle can still be loose and a little sketch. Just before reaching the saddle, where one would ordinarily go left for the Peak, look for a sizeable cairn to the right, in the talus.

The cairn above marks a third class route to the base of the Spire. The route is sparsely cairned. Keep aiming up and right for the Spire; route-finding should not be too difficult. The third-class upward traverse puts one about 70 feet below the base of the spire, at the start of what is called the first pitch, rated 5.7.

Difficulty

The Spire is astounding. I was dubious, but be assured, it really is overhanging. With no warm-up, this one is tough to hit directly. The so-called "first pitch" is rated 5.7, but we found it mostly a third-class scramble. Steve wanted a rope because he hurt his shoulder the day before leaving. I chose to forego an anchor for this first pitch, instead placing two pieces about 10 feet above Steve to secure us both to the rock, and brought him up to the

anchor at the base of the Spire, which consists of two 1" tubular webbing slings secured around a large block.

If the first pitch is not 5.7, neither is the summit pitch 5.10. I found the 5.7 section much easier; the 5.10 section, harder. Of course, crack climb ratings are hand-size dependent. My size 8½ hands did not fit a lot of the hand jams, thus requiring finger stacks and locks and rendering much of the route thin-hands. As to pro, the crack takes wired stoppers very well, and surprisingly takes more of the smaller pieces than hand-sized pieces. Besides, you need any hand-sized holes for your hands.

That buttress on the left is a bit of a problem. It wasn't obvious till we were there, that the buttress actually follows you just to the left and below for the first half of the climb. Doing the math, you can't get 2 feet from your last piece without the risk of wrecking a left ankle in the event of a fall. Three feet? A tibia. Five feet above your last piece? You may as well free-solo. This feature makes strength and confidence a necessary requisite for the route, until the obstacle is cleared through the last half of the climb, where one can relax and run it out a little.

Pro

As of the last TR I'd read, there were two fixed pieces. This number has now grown to four, the additional pieces being wired stoppers, further testament to the fact that the crack really eats stoppers nicely. They don't weigh much, so bring a few in the 3/4" (narrow dimension) down to maybe the 3/8" range. The fixed pieces make leading easier, but it's still one tough route. Don't forget that buttress right below you for the first half of the route.

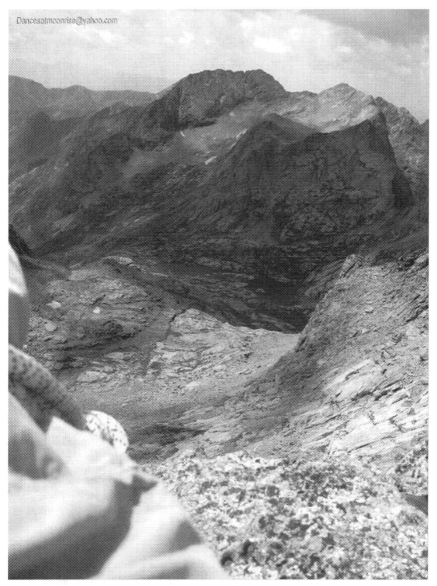

The views from the summit are outstanding.

A minimalist rack for this route might be the above assortment of stoppers, a #2 Camelot, maybe a #3 Camelot, two #1's, two 0.75's, two 0.50's, and two cams a little smaller than a 0.50 Camelot. If you wanted the full tilt, double up on the #2 Camelot, maybe also

the #3, triple up on the #1 and 0.75, and maybe the 0.50. Stoppers should be in the range of a quarter to three eighths width, up to five-eighths to three-fourths inch on the larger sizes. Camp Nano 23 biners will reduce weight, as will dyneema slings. A twin rope, 60 meters, tied in at the middle and used in standard twin style, will get you up and down the roughly 50 foot crux pitch. A single rope may certainly be used, but will be heavier to carry.

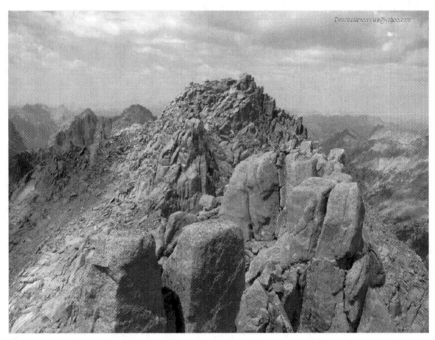

The less exciting Sunlight is over there.

Anchor

Folks have commented that the anchor leaves a little to be desired, and I wouldn't disagree. We donated a #9 hex to the project. Unfortunately, the cord (spectra) had to go around the large pin, rendering it a less-than-ideal placement. In any case, there are now four placements, none of which are ideal, but all of which are more or less equalized.

Steve planned to jug the route, so we set taut lines at the belay, using a prussic after he got started. This way, if we needed to exit in a hurry, we could just pull the rope and go. Steve got the summit in classic mountaineering style.

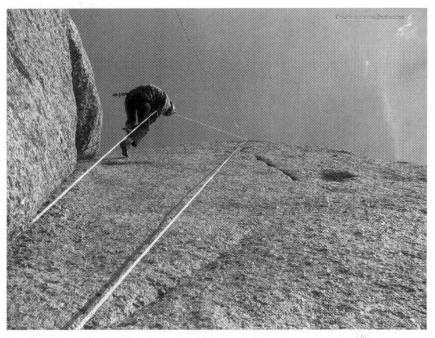

Go, Steve!

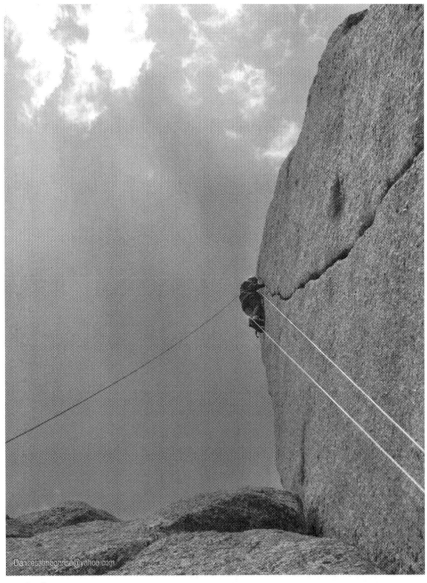

In the bag.

Extra Credit

Both of us now back at the belay, it was becoming evident the weather was with us, so we decided to go for some extra credit.

Steve provided an excellent belay as I took off, unencumbered with prior worries of cratering onto the buttress. I have to say, that was the most exhilarating three minutes of the day, or maybe the whole trip. Steve lowered one ecstatic, blown and breathless climber to the deck, where we prepared to rap. I strongly recommend top-roping the route if you have time. It's so much fun just to run the route without stopping to pro.

One 70m will get you from the summit to within a few feet of the base of the first pitch. If you have a single 60, no worries. Pull the rope and thread the rap ring at the base of the crux pitch and make it two raps. We opted to use a 70m x 8mm twin for the whole trip. We used it as a single rope on 4th and low 5th class sections, and the leader tied into the middle to use standard twin technique for the more serious 5th class pitches. This allowed 117 feet for a pitch, as a twin, and of course, allowed 117 feet of rappel length. All this for about six pounds of rope that stuffs down to about the size of a down jacket. A nice way to go.

WILL THE REAL GRAY NEEDLE PLEASE STAND UP?

Humping the Pass

Back at twin lakes, we pulled the packs and shouldered up to head over Twin Thumbs Pass. The climb was not unpleasant; the scenery astounding.

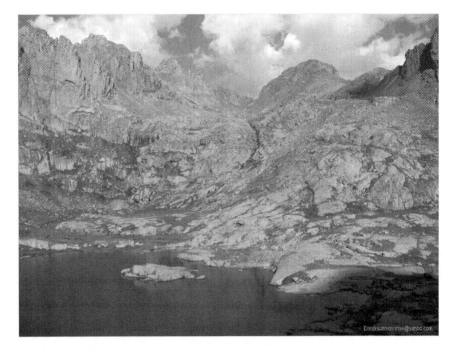

A look back at this beautiful place, and a beautiful route.

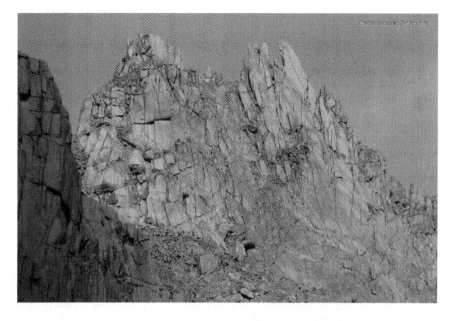

At the Pass, there are two routes down. Steve likes the east side of the pass. They each have their difficulties. The north side of Twin Thumbs Pass descends steep, loose dirt. In fact, much of the descent into Noname Basin is rough. In defense of the drainage, however, we were treated to unparalleled views, beauty, and solitude. There's a lake about halfway down. Very peaceful.

The section above the lake is mostly straightforward, with a hard bend right to get around a headwall, then back left on a sub-drainage down to the lake. The first third from the lake to the bottom of the Noname drainage was not bad. The middle third gets nebulous. You have to cross to the left side due to steep walls. Cross back to the right as soon as you can, or you end up fighting some mighty large, thick willows. The bottom third is not too bad. We got to the bottom of Noname Basin at last light, joyful to once again have a trail.

Home Sweet Home

I'd previously scouted a high camp on what, according to the map, should be relatively flat, treed terrain, near timberline. It required us to hike another 200 verts up, in the dark. Steve found a cairned trail which we believe is used to access Jagged Mountain, via the pass to the north of Gray Needle. With a little faith and a couple headlamps, we soon found a nice meadow by the creek and called it home for a few days.

The next morning proved GFS models remarkably accurate. It was raining before we even made it out of the tents. Steve allowed as how he would go out of his gourd to sit in the tent all day, so we made a plan to explore as high as we could for the next day's effort. He took the drainage to the south of Gray Needle (leading up to Noname Needle and the saddle with Peak Ten) and I took the route to a small alpine tarn on the north side of Gray Needle.

Steve's line was basically what Rosebrough describes as the route to Noname. Rather than taking the Peak Ten saddle and up the south ridge, the line ascends a shallow southwest alpine subgully to the base of Noname Needle. From this vantage point, he was able to get within a few hundred feet of the Grey Needle summit, with views of the south and west aspects of the summit block. My line took me to views of the north aspect. The north and east sides appear to offer easier weaknesses through the summit block section. However, the approach from this side is guarded by impressive walls and scree.

The sun came out for a bit in the late afternoon. Steve hit the sack and I did some recon photos from the expansive meadow just beyond camp. The late day sun was shining nicely on the peaks. For the first time, I saw clearly a magnified view of the west aspect of the Gray Needle summit block.

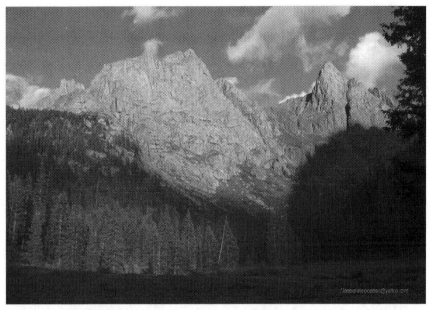

The Gray Needle and Noname Needle massif is to the far left. Middle is the Peak 10 massif. At far right is Knife Point.

Gray Needle's impressive summit block. We got to calling the rock in front the "chess piece" because it looks like the bishop on a chess board.

Summit Day

We got a good start on the day, knowing the trail well from the day before. GFS models also held nicely. We had the whole day, without really any threat of storm. Steve's feeling was that we could get closer from the south approach, so we took the line up toward Noname Needle. This line looks impressively steep from camp, but goes at third class without too much sketch.

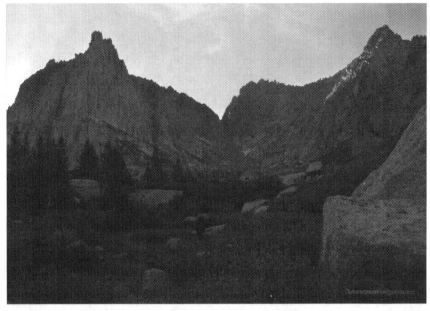

Starting up the drainage to the south of Gray Needle.

The ridgeline from Noname to Gray Needle has four rock piles. Gray Needle at the extreme west end, two sub-piles, and then Noname Needle, which itself is composed of two rock piles. The summit is the left, or north one, which is identified by a living-room sized block of rock which caps the whole thing. I wanted to go up into one of the notches between needles to see what the other side looks like. The map depicted what appeared to be a flatter area connecting all four needles, which if true, would have allowed easier study for summit block weaknesses. However, even getting up to these notches was not easy hiking.

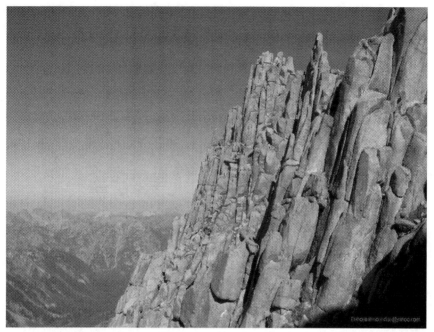

The "Coke Bottle Needle." Note the bottle-shaped rock perched on the ledge at center. It's probably 20 feet tall.

At one point, Steve decided to forego further exploration in favor of summitting Noname Needle. I was ok with that as long as he realized this meant that we'd burn the time needed to get the primary objective. I think his idea was to come back with a summit in the bag, and hoped to have a lot of terrain questions answered from the summit of Noname, as it is about 200 feet higher than Gray Needle.

I got my chance at a notch anyway. The notch between Noname and the needle just to its west, happened to be along a nice route to the base of Noname. It was comfortable scrambling, and Steve would have been OK with it, had it not been for the shoulder. I took the rope up and set a belay. The other side of the notch looked nothing like what the map appeared to depict. It was more of the same; rock and steepness. But from here it was an easy walk to the base of Noname's central weakness, so we headed over and geared up to climb.

Laura Janca

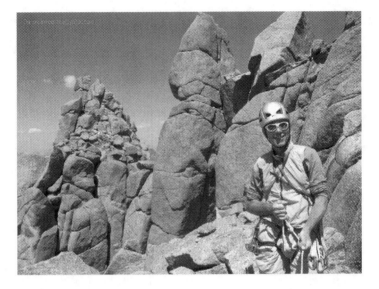

Noanchor Needle?

Steve thought the route was rated 5.8, which seemed about right. We used twin technique; I tied into the middle. This got us up the central weakness, where we would have had to break up the pitch anyway, due to rope resistance. This was about a 100' pitch. I used three pieces for the lead. A #10 hex, maybe a #2 Camalot, and maybe a #1 Camalot. A #3 worked well, along with some smaller cams, for an anchor.

We took a fourth class second pitch up and around to the base of the summit block, where we swung leads, putting Steve on the summit. The views were amazing. One interesting finding is that these needles nearly align perfectly from the perspective of the location of our camp. From camp, we could only see three needles.

Unfortunately, from the summit, for the same reason, we saw nothing of Gray Needle or its elusive north and east sides.

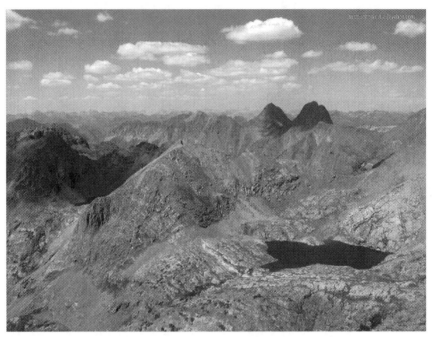

Arrow and Vestal seen from the summit of Noname Needle.

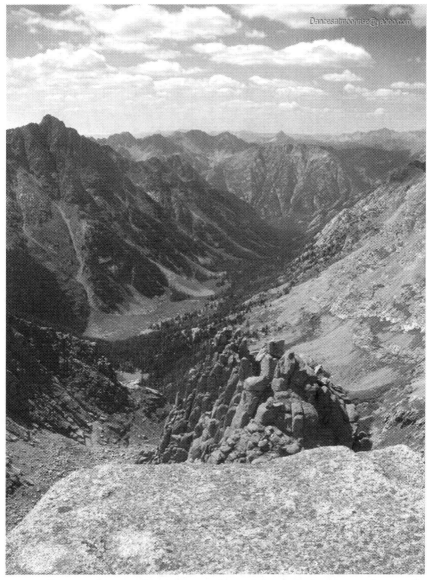

Our camp is in the small green meadow at lower left center. The needle at center is a sub-peak which obscures Gray Needle and veils approach terrain.

Yet another mystery that really puzzled me, was zero evidence of any rap anchor. I looked everywhere but the south summit, which

we didn't ascend. I would have thought the top of a 100 foot first pitch would be the most logical place for a rap anchor. Nothing. There were rocks piled up on the summit, so people get up here, but how do they get down? That 5.8 section is too stiff for most people to comfortably downclimb, unprotected. The mystery will have to remain unless someone who has been up this peak will please tell us how they got down without leaving a rap anchor! :)

After getting off, the flat-tops above us were still flat, barely grey, and it was apparent we had some time for extra credit. Tomorrow was pack-out day, so we wanted to take this few hours to scout.

Gray Needle: Up-Close Recon

We were able to scramble up onto the southwest aspect of Gray Needle, within about a full rope-length of the summit block (though roped climbing would likely involve more than one pitch.) What lies above is deceptive, because it appears different from different aspects and elevations.

Steve thought he saw what looked like a fourth-class ramp to the summit. A short scramble up and left revealed his ramp to be a pretty serious fifth class weakness. We found several possibilities, but nothing that looked like typical easy mountaineering fifth class stuff. I really wanted to see the north and east sides, but at this point, we didn't have much time, and even less energy. To get to the north side, we'd either have to descend and re-ascend in the drainage to the north, or rope up and try to traverse up and over. This late in the day, those were not good options. It was a good recon, and we saw a lot. The south or west side might go. The north or east side might be easier. To be continued....

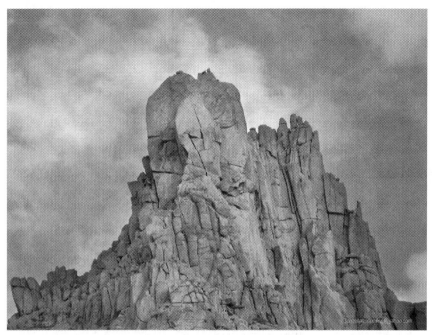

Goodbye for now, beautiful, mysterious Gray Needle...

Last Train Home

Back in camp, Steve was quite animated. We didn't get to bed till late, and I was slow getting out of camp Wednesday morning. We made good time down Noname canyon, both seeing it for the first time. The trail was mostly good, with occasional areas where it became harder to follow, especially around an old cabin. How good was our time? Steve called it "ankle breaking speed."

This all changed when we got to the Animas. The trail from Noname and Animas over to Needleton is tricky. It ascends about 150 verts (but feels twice that) to get above the steep walls of Ruby canyon at the Animas.

If you come in from Needleton to ascend Noname canyon, be sure not to miss the cairn marking the trail up Noname Canyon. It is probably five minutes or maybe ten minutes north of a huge

ceramic insulator thing laying on the ground like a cairn; one of those high-tension line insulator things.

There are a couple of creek crossings. Watch for the cairns, they usually tell you the best place to cross.

There is one confusing area about five or ten minutes north of the Needleton drop-off, in a large meadow. There are some stumps set up around a fire. The north end of the meadow has the trail that goes over to Noname. As we came back, I walked a straight line through the meadow, as there were no cairns, and found a cairn on a stump, and more on the ground, as one enters the trees, marking a good trail, at the south end of this meadow. However, Steve said this is wrong. He had just entered the meadow from the north end, and took a right turn. I headed toward the river and found the trail down below a headwall. He thought maybe the other one (at the south end of the meadow) went to Ruby. If you come up from Needleton, you want the trail going out the north end of the meadow, which takes you to Noname. If coming back from Noname, you want the trail going out the west side of the meadow (downhill toward the river.) The train drop-off is only maybe 5 minutes from here. We made great time till we hit this whole Animas section. It's probably less than two miles but took us 85 minutes. Total time from our high camp was about 3:15, moving faster than we'd have liked.

Looks like we may be going back in next month for more. It will be interesting to see if we can find the weakest line to the summit. It will be especially exciting if we find that reputed old bolt ladder on the summit block; not that 60 year old rusty quarter-inch buttonheads with beer-tab hangers will even hold body weight at this point.

A work, a mystery, in progress...

Finishing the 14ers:
Capitol Peak

Route: Capitol Peak, Northeast Ridge
Approach: Capitol Creek TH ("Ditch" Trail)
Date: 9-25-11
Length: 18 miles RT
Vertical: 5400 feet
Ascent Party: Dancesatmoonrise

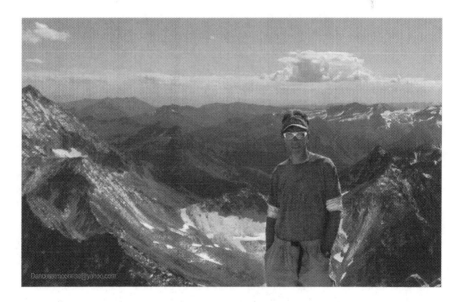

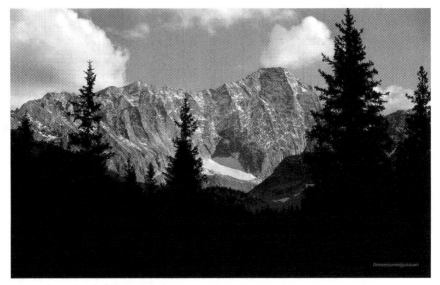

Capitol Peak in early autumn attire.

Prologue: Capitol Peak, the PLB, and the 14er Quest

Before I knew there would be any fourteeners in my future, I'd already gazed in awe, wonder, and fearful respect upon Capitol Peak and the Snow-Cap Traverse. In those days I used to enjoy getting into wilderness places where most folks didn't or couldn't go. When I'd heard about the Pierre Lakes Basin, I was excited, but couldn't find any reasonable access on the maps. Initially I thought it would mean rappelling in from somewhere around Siberia or Avalanche, so I shelved the idea for the time being.

I think it was 2001 when I first gave it a go up Bear Creek. It didn't go. Two tries later, I made the day hike; it was a long one, but well worth it.
I'd seen this incredibly pristine place for the first time, and could not believe the awesome magnitude of what I was witnessing. By 2008, I went back up for an overnight trip. I was smitten with the idea of doing the Snow-Cap Traverse from the PLB. It looked

blissful and at the same time positively frightening. Capitol Peak reigned supreme over the entire huge cirque. It seemed like an impossible dream to ever step foot on this mountain.

I had no actual plans for it, though passion for this mountain remained securely in my heart.

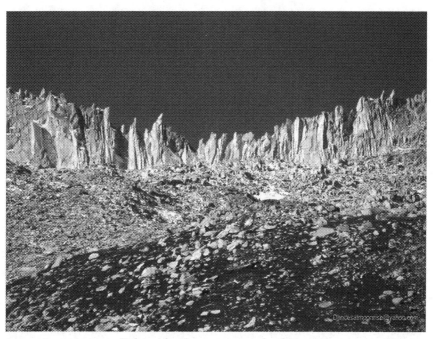

Snow-Cap traverse: "The ridge becomes an absolute nightmare, with car-sized teetering gendarms and huge scalloping flakes on the walls below them..."

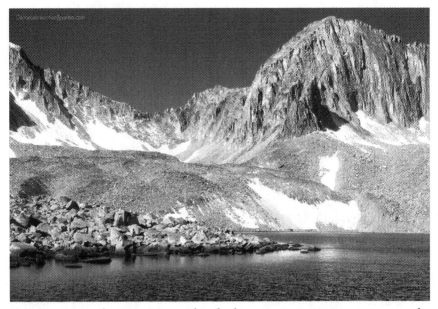

Point 13,431 on the Snow-Cap ridge, looking majestic as it towers over the lower Pierre Lake.

Another year passed. In late 2009, the summits of Yale and Belford beckoned. I had never considered 14er'ing because I'd always heard the 14ers were crowded. But to my surprise, I had these summits to myself. The trick was a late start under great weather – everyone had this curious compulsion to be off the summit shortly after Noon, and I found myself basking in the sun around 1:30 pm with the summit all to myself. I enjoyed it a great deal, but had no plans to complete the 14ers. After two more in October that year, I figured the season was pretty much done. That is, until Steve Gladbach took six of us up Quandary Peak on Halloween, 2009.

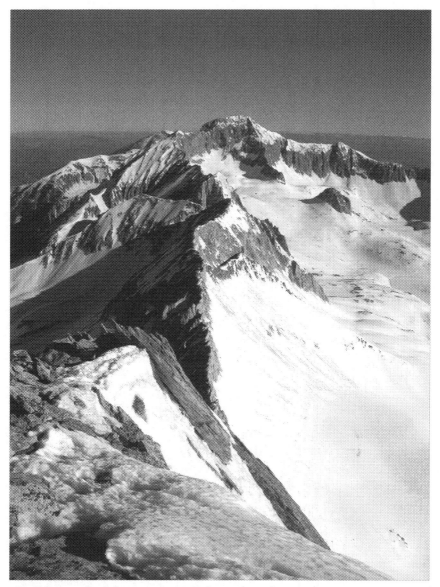

The other end of the Snow-Cap ridge: taken during a May 2010 ascent of North Snowmass Peak.

For me, that totally demolished some mental barriers. In one short trip, the mental connection was made that 14ers can be done during the "off" season. I got more interested, and Steve helped me

with advice on which ones would be reasonable to attempt next, as winter approached. Yet, I still had no plans to do all the 14ers. By the time winter was over, I'd had a dozen calendar winter ascents, and maybe twice that many 14ers in all. It started to dawn on me that maybe I could polish off the list. By summer's end, I'd had 50 in the bag. Then a curious thing happened. I didn't want to finish. I was having too much fun, and was worried that I'd lose motivation by wrapping it up. By winter, the second go-round added another thirteen ranked 14ers to the winter list, and one new 14er (Little Bear) to the overall list. It seemed reasonable to finish out the overall list next summer or fall. Some difficult peaks remained, as well as a choice for a finisher.

By this point there was plenty of experience, and though the remaining peaks were among the most difficult, none would be an unreasonable challenge.
Yet, Capitol Peak, alone, stood as the magnificent, penultimate, and covertly terrifying quest that lay ahead. Clearly, I'd long ago elevated it to the status of impossibility. Would it be too much pressure for this mountain to be my finisher? Still, what more worthy way to celebrate completion than with this noble peak?

Waiting out an unusual September

In early August, great weather graced a fun road trip to polish off the remaining pre-finishers: Mount Wilson, Wilson Peak, El Diente, and Maroon Peak. I had banked on typically warm, dry September weather for the Capitol Peak finisher, but was rebuffed with torrential rains the first half of the month, so I waited. Then by mid-month, it snowed a foot in the Elks: most unusual. I really didn't think I was ready for Capitol in anything resembling winter conditions.

The Capitol Creek drainage with Capitol Peak in the background.

Every year, it seems to take the first good snow to bring Indian summer. I'd hoped to wait for decent melting on the difficult fourth class sections of the route, since much of it is south-facing, and Indian summer had come into full swing. Yet the nagging reality remained that it was only getting later in the year, with colder night-time temps and an ever-increasing likelihood of a shut-out snowstorm.

By Saturday, September 24, 2011, a developing weather window for the following week appeared to be faltering. I wasn't taking any chances with this one. I quickly threw a pack together, got groceries, went over to say good-bye to the new GF, and came home for a relatively sleepless night.

Finisher Day

I can't imagine I'm the only one that wakes up before the alarm on peak-day. Definitely dragging at 4am, I'm out the door at 5, and making record time to the TH, given a surprising lack of traffic on this gorgeous Sunday morning.

Pulling into the TH parking, the north side of the peak looks depressingly snowy, but I know the south side will be better; maybe even passable.

By 8:40 I'm moving. The Capitol Ditch trail is not bad at all this time of year. Much of the water is gone, and so are the cows. I'd hoped to hit peak colors; the aspens are just now turning in the Elk range. By 10:55 I'm at Capitol Lake, about six miles in.

The GF had been worried and wanted to at least join me for Capitol Lake. I can see why Aaron did all, and Steve most, of the winter 14ers solo.

Sometimes when you're worried about things possibly being sketch, it's just easier to go alone. She and I can start with something easier after the finisher. Meanwhile, I break personal tradition and carry a cell phone for the first time on a 14er, so I can check in with her.

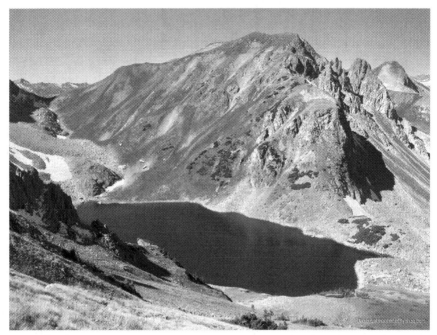

Capitol Lake.

Up ahead I see what looks like a group of two or three making way for the Capitol-Daly saddle. By 11:20 am I find a half-open day-pack at the saddle, and no people. I also find lots of snow on the back side. This is not looking so good. At the least, the fast pace to this point is going to take a back seat.

Entering the huge field of talus blocks partially covered in snow, I'm not enthused. I aim for tracks across a snowfield. This turns out to be a mistake.

An older gentleman with a young woman tells me the way is straight ahead (due south) and that the snow becomes slick and difficult, to the point that they had been forced to turn back. I figure he knows what he's doing because this is his third time on Capitol.

The old man's steps lead toward the prominent notch on the Clark-Capitol ridge. As I approach, the snow indeed becomes slick and

107

difficult in approach shoes. I stop to don spikes and axe, which helps. Stopping again, I need gaiters. Halfway up the slope I know this isn't correct, though I want a view of the Pierre Lakes Basin through the notch. The approach shoes really aren't kicking steps in this slick stuff very well, and it's getting late, so I reverse course and make for the dry stuff to the west, heading up toward K2.

You can't see K2 from here, but there's not too much that's higher elevation that isn't on-route, so you just head west toward the ridge, and K2 appears. With the southern exposure this time of year, Clark's ridge shades much of the terrain near it, so the trick is to stay further north, out of the shadow of the ridge, while heading west toward K2. There are some beautiful, very large orange-colored blocks here that are almost like walking on sections of concrete side-walk: a welcome relief from the grind. Higher up, it's easier to approach the ridge for views over the other side, where I discover dry conditions and three climbers on the infamous knife-edge of Capitol's NE ridge. I'm excited to finally be entering the business district. It's nearly 1pm. With a calculated cut-off for the summit by 3pm, time is a little tight, but the rest of the way looks clear, dry, and close.

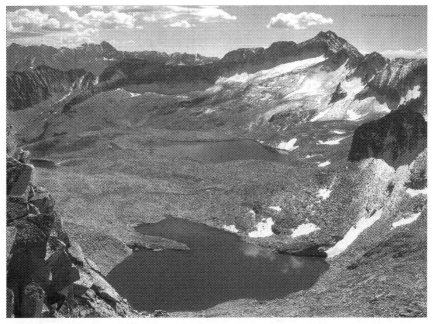

The phenomenal Pierre Lakes.

K2 has this reputation for being the hardest part of the route, but it looks fairly benign. Still, I already know I don't want to go around the north side of it due to the snow. To my surprise, the south side seems to "go" – at least for a ways, until clearly 5th class terrain is reached, where one then experiences Sudden High Altitude Realization. In this case, the realization is that while fifth class climbing ability can be helpful in the alpine, it can also get one into trouble in the alpine. The rock over here is dry, it's solid, it's fifth class, and it's getting steeper. I turn up to gain the top, where the crew of three is directly ahead, just having completed their return across the knife-edge. Turns out it's Nick with Ben and Alli.

Nick, great meeting you guys!

Peak Moment: The "Knife-Edge"

The crew tells me there's one more party of two just getting to the knife-edge now, and after that I'll have the mountain to myself. At the knife-edge, I meet Bryan and Connie, who graciously offer to get photos across the knife-edge. (Bryan and Connie, nice meeting you guys, and congrats on finishing the 14ers last week! Interesting that all four of us were on Bierstadt that day...)

It's 1:30 pm. The section ahead is everything I'd anticipated – steep, exposed, solid. The knife-edge is reputed to be the most difficult part of the route, yet most trip reports say that either K2 or the ridge and face below the summit are. Without question, though, the knife-edge is the most dramatic feature of this incredible route. With nearly two thousand vertical feet of exposure on either side, many people do the butt-scoot across this section, throwing one leg over either side of the knife-edge, and scooting across. Others traverse slightly below the top, using footholds on the south (left) side, while using the top of the knife-edge for hands. A few stand up and walk across the top. Connie, still on the other side, tells me to go first, as she wants to take her time with it.

At the moment, the knife-edge ridge speaks to me. I'm feeling good; I want to man-up and walk across. Capitol Lake, two thousand feet below, is to the right. The Pierre Lakes are incredible, 1400 vertical feet below, to the left. As I gaze into the PLB, time takes me into the past, back to the basin, looking up at Capitol Peak and the NE ridge. Can I see a tiny dot a few years into the future, about to walk across?

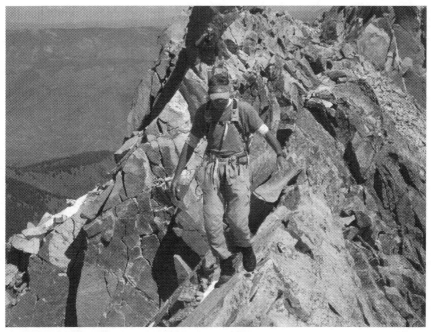

Peak moment: With over 1000 vertical feet of exposure on either side, Capitol Peak's infamous "Knife-Edge" requires intense focus and concentration to stand up and walk across.
There would be no dishonor in resorting to the "butt-scoot" here.

Laura Janca

What "down" looks like from here.

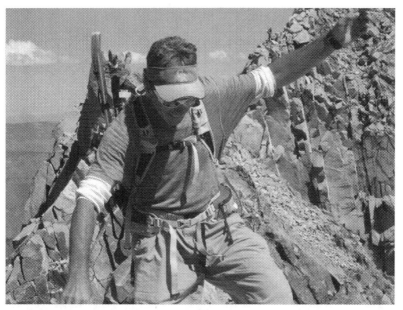

OK, you know you're having too much fun when you can get a little off-kilter over big exposure and still smile!

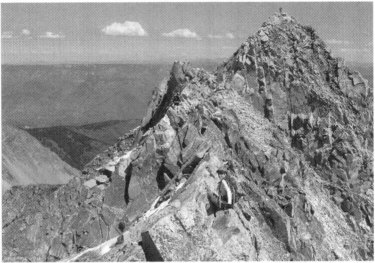

The butt-scoot is a highly valued mountaineering technique in this setting. Here's Connie demonstrating the technique in a most elegant fashion, as Bryan, only slightly nervous, looks on.

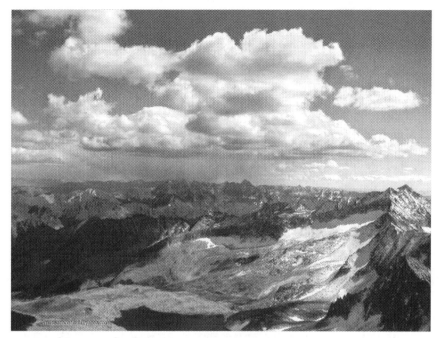

Approaching weather? Time to get moving...

I'm in a dream. Can I actually summit Capitol Peak? Will it happen today? The knife-edge goes smoothly. I get some shots of Connie crossing; we say good-byes. I turn to the mountain, alone, in awe and respect, and ask permission to gain the summit this day.

I know route-finding will be difficult. All that has been done to this point has been preparation for this impossible goal. I chose to do the route-finding for our group on Pyramid Peak last year, knowing that it is one of the more difficult routes, and also knowing I was blessed with very competent partners who could spell me in the event of error. It was like a safety net. Last month I did the route-finding for a small impromptu group on Maroon. Maroon was the most difficult, for me, of the standard 14er approaches, in terms of route-finding, but it went without a hitch. Today, I'm alone. Everyone is headed down off the mountain. It's late. It's quiet. I take a quick inventory.

Let's see. Summit ridge; check. Only 400 verts to the summit; check. A steep face on the sunny side, with ledges for traversing; check. Solid rock ribs leading back up to the summit ridge along the way if needed; check. Hmm...sounds not a great deal different from the other 58 fourteeners I've been on. Let's roll.

The route to the summit goes smoothly, until the very last section. I'm in a steep gully, and cannot discern a definite route either cresting the far rib out of the gully, or one heading up the somewhat loose gully to the summit ridge. The summit is close, so I get past some loose stuff to get on one of the steep but more solid ribs and take it to the summit ridge, where the actual summit is only another hundred yards or so of pleasant scrambling along the ridge-top. A mood of business-as-usual does not seem to give way to the realization that I've just summitted Capitol Peak, and just finished all 59 fourteeners (58 + North Massive.) As I'm later to learn, it's going to take a few days for this to sink in.

What does sink in is the incredible alpine terrain in this part of the range. I've dreamed these views for so long, and now I'm here witnessing Snowmass, North Snowmass, the entire Snow-Cap traverse, the majestic Pierre Lakes Basin, the Maroon Bells in the distance...

The legs are hot to descend into the traverse, while the ol' brain says, "Hold on there, pardner, it's 2:15pm, and you still have to get down!"
Oh, yeah...that...

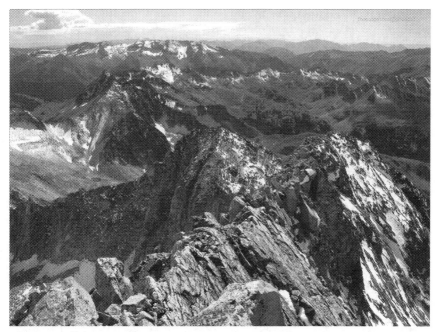

The start of the Snow-Cap Traverse.

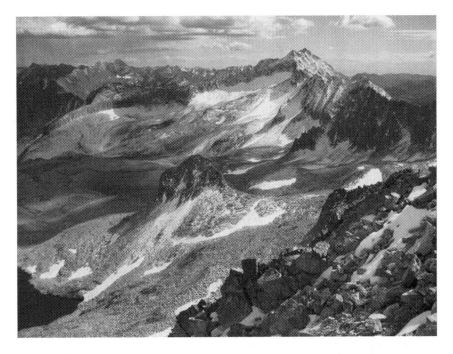

So what does this remind me of, sitting in the warm late-season sun on a summit, all to myself? That first trip up Denny Creek two years ago, witnessing the last of the Indians marching off the summit ridge saddle, while ascending into the awe, beauty, and solitude of a high alpine summit.

This one was a little harder, but they are all mountains, and they all sort of work the same way. The long-term mental block has suddenly been blasted free, on this, the last new Colorado 14er summit. Ken Nolan is right. Fear Confrontation Therapy really does work. He is also right, that this moment is not so much a finish, as it is a beginning, a birth - the birth of a mountaineer.

Some quiet reflection in the warm sun, a brief supplication of gratitude, and it's time to reverse steps with the hope of making it back to the car by dark.

In the days following the finish, the accomplishment finally begins to sink in. That I have been able to witness such an incredible journey has been only by His blessing and grace. I am humbled to be a 14er finisher, to have witnessed the great high works of His hand all around us, to have journeyed to the highest places where Earth meets Sky.

A few words about the descent, just to finish the story, and to perhaps offer some beta for future travelers attempting the route. Getting off the summit and back across the knife-edge goes without a hitch. The same is true for K2, despite some snow on the north side. There is a nice rock rib at the easternmost extent of the north face proper on K2, which remains relatively dry in current conditions, allowing access more or less along the standard line up and back over K2.

Descending into the talus field works best staying toward the left (east) side of the gully, particularly when there's snow in the shadow of the Clark-K2 ridge. Large flat red-orange blocks are found in this area, facilitating travel. The best line for cutting below the Capitol-Daly ridge remains debatable. Benners and USA Keller prefer a line somewhere below the cliffs and above the lower gully. Staying high on the traverse back over works relatively well, though after a bit, I'm into crossing ribs and gullies. One of the ribs works well to get back down to the upper gully, nearing the Capitol-Daly saddle. I'm surprised to find a fixed rope here. The snow and ice is a little troublesome, as is some loose talus, occasional remarkable for its size.

At the Capitol Daly saddle, difficulties are essentially over. I dig out Red's cell phone and give her a call. I know little about cell phones, so have no reason for surprise when the darned thing actually works. Descent off the saddle is graced by the warmth of the southwestern sun, now nearing the horizon. Calculations put me at the car at last light. Perfect. I holler over toward the small mesa above the lake where Nick and his crew, and Bryan and Connie, are camped, and wave good-bye, as I start the long trail back.

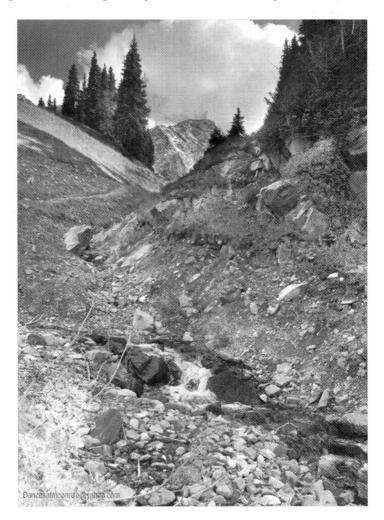

Sure enough, I avoid pulling out the headlamp only by mere minutes, arriving back to the car at last light.

Somehow, no matter how many of these you do, the last mile will forever be the longest...

Post-script

I wish to thank all of you, our mountaineering and climbing community, for having made such a positive impact on so many of us in terms of our growth as mountaineers. I know that I personally will be forever indebted to many who have come before us, offering their advice, encouragement, and camaraderie. A warm thanks, guys.

Printed in the United States
By Bookmasters